IMAGES
of America

MILWAUKEE'S HISTORIC
BOWLING ALLEYS

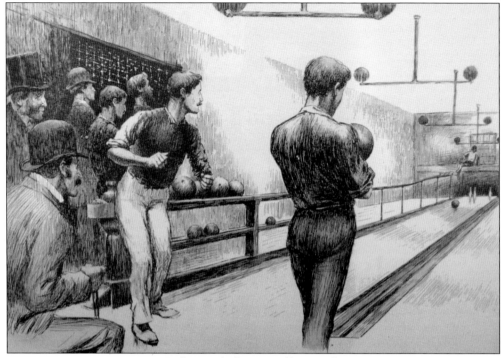

Roll away, boll away, roll away all,
Set up the pins, boys, the price is but small;
Off with the coat now, and roll up the sleeve,
And at it, my jolly lads—heave away, heave.

With the arm's muscles bare, for one hour, fling
Dull care to the air, and at five cents a string;
Roll away, boll away, hearty and strong,
'Twill develope the man, and his life thus prolong.

Who would sit moping all day in his chair,
When pleasure and profit, so rich and so rare,
Can be had and that, too, at such a cheap rate,
At the Bowling Saloon of the old "Badger State."

Come, then, "young America," foreigners, too,
Here's rolling and bolling—not just for the few,
But for old and for young, for little and great—
Come join in the fun at the old "Badger State."

—"Badger State Saloon Triumphant!"
Daily Free Democrat, 1856
(Photograph courtesy of International Bowling Museum and Hall of Fame.)

ON THE COVER: In 1917, the Milwaukee Athletic Club, first formed in 1882, moved to its present facility on Broadway. There were eight lanes for bowling in the basement, which continued to be used until a major remodel in 1975. Here, a women's team gets set to strike. (Courtesy of Milwaukee Athletic Club.)

IMAGES
of America

MILWAUKEE'S HISTORIC
BOWLING ALLEYS

Manya Kaczkowski

ARCADIA
PUBLISHING

Published by Arcadia Publishing
Charleston, South Carolina

Printed in the United States of America

Library of Congress Control Number: 2010928671

For all general information, please contact Arcadia Publishing:
Telephone 843-853-2070
Fax 843-853-0044
E-mail sales@arcadiapublishing.com
For customer service and orders:
Toll-Free 1-888-313-2665

Visit us on the Internet at www.arcadiapublishing.com

This book is dedicated to my husband, Jerry Kaczkowski, who taught me about love and about finding my pocket; and to each member of the Stone Drive Bowlers, including the late Jim Stark.

CONTENTS

ACKNOWLEDGMENTS

I would like to thank the following individuals and organizations that were kind enough to share their photographs and stories with me: Kandy Birmingham (Milwaukee USBC Women's Bowling Association), Tim Brady (American Serb Hall), Carey Catania (Motion Plus Lanes), Steve Cooper, Charles Damaske, Ellen Engsethe (University of Wisconsin-Milwaukee Archives), Don Janke (Greater Milwaukee USBC Bowling Association), Mike Kozinski (Bay View Bowl), Marlene and Tom Mather (Mather Lanes), Ron Nowak (Milwaukee Athletic Club), John and Lynn Okopinski (Falcon Bowl), Barb Rydzewski (Bob E Lanes), Doug Schmidt, Marcy Skowrinski (Holler House), Sandy Stark, Slava Tuzhilkov (Landmark Lanes), Ed Vahradian, Jr. (Ed's South Milwaukee Arcade), Milwaukee Public Library, Milwaukee County Historical Society, The Rave/ Eagles Club, and Wisconsin Historical Society.

A special thank you to Amy Polley of the International Bowling Museum and Hall of Fame for allowing me to search through the archives, and to Annette, who dug right in there with me.

INTRODUCTION

Choose your weapon and step up to the approach. Make your stance . . . now—one, two, three, four, five steps, a measured backswing, and a perfectly aimed toss down the lane. Then watch, holding your trophy-top pose. Crash! Strike!

Beer and bowling . . . bowling and beer. It doesn't much matter how you say it, the two work well together, and both had a stronghold on Milwaukee for more than 100 years. Nearly all of the big breweries left town years ago, with an ever-growing number of microbrewers stepping in to help fill the void. But bowling lives on in Milwaukee, maybe not in the same large-scale, "bowling capital of the world" way it did during much of the 20th century, but it is still there, in the oiled planks and carpeted walls of dozens of historical establishments. Through the thunderous rumble of pins, the smack of high fives, and the occasional cheer, bowlers know that the sport lives on in Milwaukee.

The tradition of bowling goes way back, possibly to ancient Egypt. In 1895, archaeologist Sir Flinders Petrie discovered artifacts resembling balls and pins inside the tomb of a child buried between 5000 and 3000 BC (documented in *Naquada and Balas 1895*). Also in Egypt, Italian archaeologists discovered, in 2007, what appears to be a rudimentary bowling alley that likely dates to around 300 or 200 BC.

Although specifics vary, it is generally accepted that the current method of bowling began in Germany somewhere around 200 BC. "Kegling" was a game with nine wood sticks ("kegels") that could be toppled when stones were thrown. Some say the tradition began when a Bavarian priest set up a kegel in his churchyard, called it a heathen, and asked parishioners to throw a stone at it. If it toppled, all was good. If the kegler missed, his soul required cleansing. Even today one bowler may tell another that he "better go to church tomorrow" when he leaves a pin standing.

Other historical forms of the game include Dutch pins (Netherlands), *petanque* (France), lawn bowling (England), and *bocce* (Italy). Skittles is another variation, with players throwing a "cheese" (similar to a heavy Frisbee) at nine "skittles" (birch pins).

In Milwaukee, the tradition of bowling gained tremendous popularity in the late 1800s, through the efforts of local aristocrat brewers—the Uihleins (Schlitz), Jacob Best, Capt. Frederick Pabst, Valentine Blatz, and Frederick Miller. They began opening bowling alleys in places like Schlitz Park, which also held a concert pavilion, dance hall, and refreshment parlor. But even before the outdoor beer gardens, there was bowling in smaller pubs. A newspaper account from 1855 deplores the condition of the "drinking saloons, billiard rooms, and bowling alleys" in Milwaukee. And in 1863, the *Milwaukee Sentinel* disclosed that Milwaukee had a total of 500 retail liquor dealers, 26 billiard saloons, and 12 bowling alleys. The population at the time was just 50,000.

Things really got rolling when Abe Langtry opened the first large-scale bowling center in the city—24 lanes—and arranged to bring the American Bowling Congress (ABC) national tournament to Milwaukee in 1905. The event was such a success that Langtry was elected secretary of the ABC shortly afterward. He ran the organization from his office on Wisconsin Avenue for the

next 25 years, earning Milwaukee the unofficial title of "America's Bowling Capital." The ABC (now United States Bowling Congress (USBC)) headquarters were in Milwaukee until 2008.

Sadly, of the 200 or more bowling alleys opened in greater Milwaukee before 1950, fewer than 20 are still in existence. Some still have wooden lanes and hand scoring, but only two still use pin boys (Holler House and Long Wong's). There are plenty of newer places in town to bowl. But it's the old lanes that really beckon—Bay View Bowl, which still has the window that the foul judge had to peer through; Holler House, where joshing with owner Marcy Skowrinski is even better than bowling downstairs in the two ancient little alleys; and Mather's, where the Milwaukee Electric Railway train used to stop right outside the door, bringing tourists in to visit Muskego Beach and the old amusement park.

These alleys, however, are definitely not stuck in the past. Bay View Bowl is open all year round, with its funky Rock 'N Glow Bowl, drawing a youngish crowd from the surrounding neighborhood. Landmark Lanes is a small underground city all its own, with three bars, 16 lanes, 9 pool tables, and an arcade that features an electronic dance machine. Falcon Bowl has dartball and cribbage leagues, and a strong following from its neighbors in Riverwest. And Motion Plus has more league bowlers than it did 10 years ago.

But this book is not only about the lanes—it's about the people. Teams like Heil Products, Kornitz Pure Oil, and Knudten Paint made Milwaukee famous not only for its lanes and the ABC, but also for its champion bowlers: people like Hank Marino, Ned Day, and Esther Ryan. And for every famous bowler, thousands more regular folks have slipped on their bowling shoes once or twice a week for an evening of team sport and camaraderie. In the 1970s, television shows *Happy Days* and *Laverne and Shirley* managed to capture the essence of a time when everybody either bowled on a team or knew someone else who did.

This publication is meant to be a tribute to the historic alleys opened in America's Bowling Capital—a pictorial recollection of the buildings, the people, and the sport that contributed to the overall image of Milwaukee. Even though the USBC has left Milwaukee for Arlington, Texas, the mom-and-pop lanes are still here, and still worth visiting. Wisconsin has more old-fashioned bowling alleys than anywhere else in the world, and Milwaukee is the center of it all—if not geographically, at least in a kegler's heart. That's why places like Holler House and Falcon Bowl will never install automatic scoring machines, and Koz's Mini-Bowl always draws a crowd.

One

BEER, BOWLING, AND HOW IT ALL STARTED

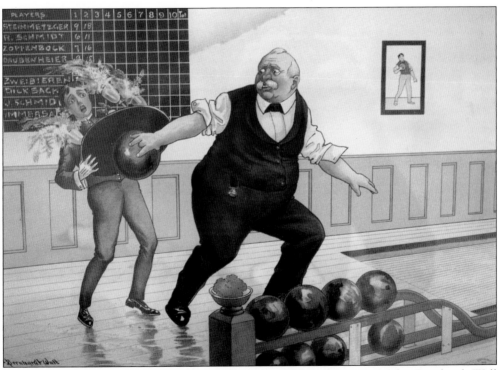

This is something a bowler definitely doesn't want to see on the lanes. In this Bernhardt Wall cartoon from 1905 printed by the Ullman Manufacturing Company, the unfortunate server would have been better off setting the suds on a table. (Courtesy of International Bowling Museum and Hall of Fame.)

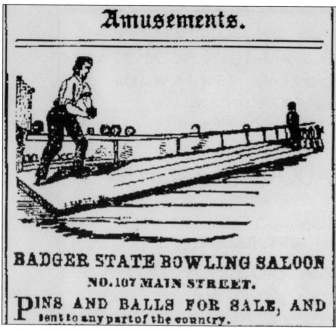

As early as the 1850s, ads for bowling saloons began to make their way into Milwaukee newspapers. Saloon keepers had lanes installed in their establishments to provide a sporting activity for drinking customers. Both the Badger State (*Milwaukee Daily Sentinel*, 1860) and the Young America (*Daily Free Democrat*, 1854) Bowling Saloons were on Main Street, today known as Broadway.

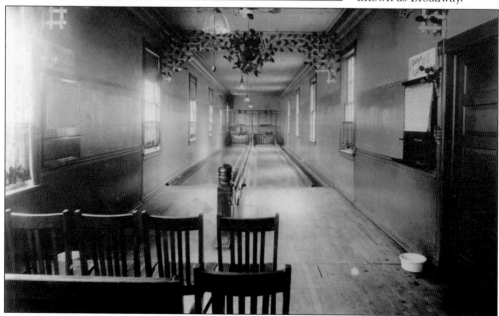

This two-lane alley is typical of what could be found in saloons in the late 1800s, with a scoreboard on the wall and a spittoon. (Courtesy of Milwaukee County Historical Society.)

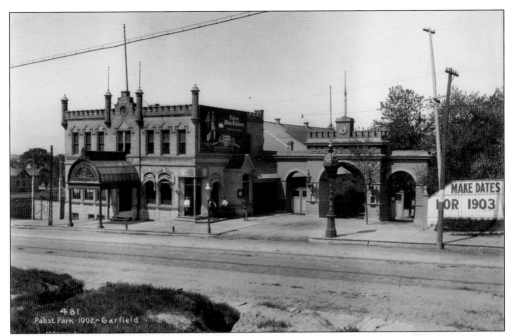

In the late 1800s, Milwaukee's beer barons began creating gardens for their patrons. Many featured bowling alleys for recreation. Pabst Park, shown here in 1902, was located at Third Street and Garfield Avenue. Frederick Pabst opened the park in 1890, and it was quite an exciting establishment, with a roller coaster and Wild West shows. Today the neighborhood that occupies this land is also known as Pabst Park. (Courtesy of Wisconsin Historical Society.)

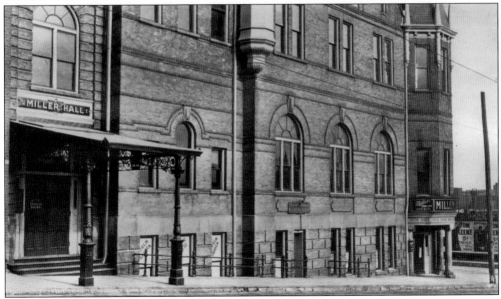

Frederick Miller, a hardworking but fun-loving brewer from Germany, opened a beer garden on the bluffs above his brewery—the perfect place to drink Miller beer and roll a few bowling balls. Miller Hall, shown here, was another recreational establishment. By the time of Prohibition, the Millers owned about 300 saloon properties, plus hotels and theaters. Note the words "Palm Garden" on the three ground-level windows. (Courtesy of Wisconsin Historical Society.)

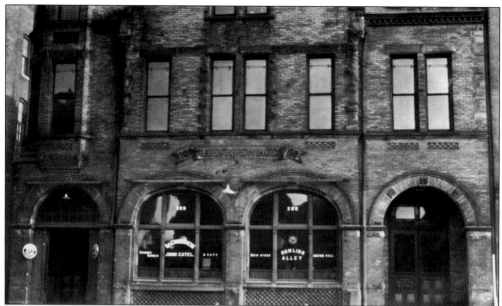

Suds and recreation could be found at this saloon, established in 1886 by the P. H. Best Brewing Company. Frederick Pabst took over the brewery from his father-in-law, Jacob, three years later and changed the name to Pabst. It was common in those days for brewers to own saloons. Note the "Summer Garden and Café" and "Bowling Alley" signs in the windows. (Courtesy of Wisconsin Historical Society.)

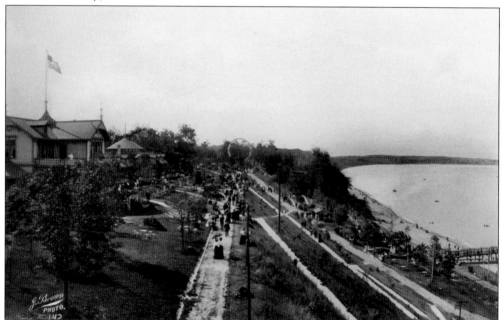

Located on Lake Michigan across from Bently's Whitefish Bay Inn (today known as Pandl's restaurant), the Pabst Whitefish Bay Resort drew Milwaukeeans and travelers alike between 1889 and 1914. Both a train (on the "Dummy" line) and a steamer (the *Robert C. Pringle*) brought visitors from Milwaukee to the resort, where they could relax with their friends in various social and sporting pursuits. (Photograph by Joseph Brown, courtesy of Wisconsin Historical Society.)

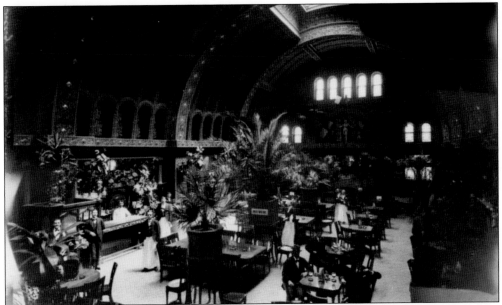

In 1896, the famed Schlitz Palm Garden made a splashy entrance onto the Milwaukee downtown scene, in combination with the Schlitz Hotel on the corner of Third Street and Wisconsin Avenue, with drinking, dancing, and bowling possible in an indoor garden atmosphere. Many famous politicians visited the Palm Gardens, including Woodrow Wilson, who made a speech there on his first campaign tour for president. The Palm Garden closed in 1921 and unfortunately did not reopen after Prohibition. (Photograph by Albertype Company, courtesy of Wisconsin Historical Society.)

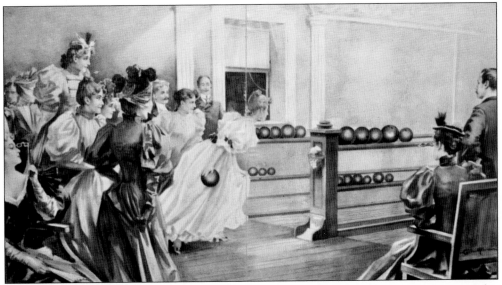

Bowling was usually thought of as a sport for men, but as this print by American artist John Leon Moran (1864–1941) portrays, women took part in the sport as well. Note the various ball sizes in this painting, representing the lack of standard equipment. Perhaps this also shows the transition from smaller balls and pins to the larger balls and pins still in use today. (Courtesy of International Bowling Museum and Hall of Fame.)

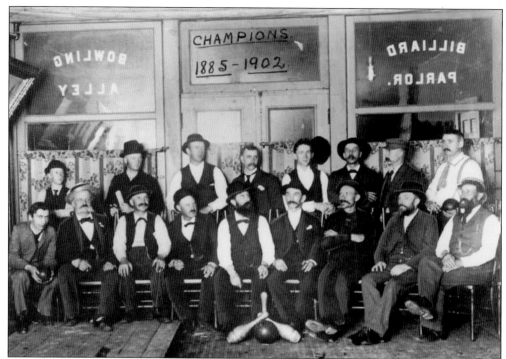

Even before the American Bowling Congress (ABC) was established in 1895, bowling had taken root in Milwaukee. German immigrants formed teams and began holding competitive matches. This photograph of a champion team from 1885 to 1902 depicts an early Milwaukee bowling club in a local combination billiard parlor/bowling alley. (Courtesy of Milwaukee County Historical Society.)

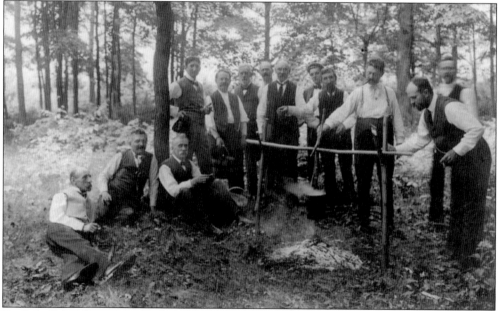

Bowling clubs often pursued leisure activities outside of the lanes. Here the O. K. Bowling Club is on an outing at Neumiller Park in Milwaukee in 1904. Frank Rost and A. Richter demonstrate their chef techniques to the rest of the club. (Courtesy of Milwaukee County Historical Society.)

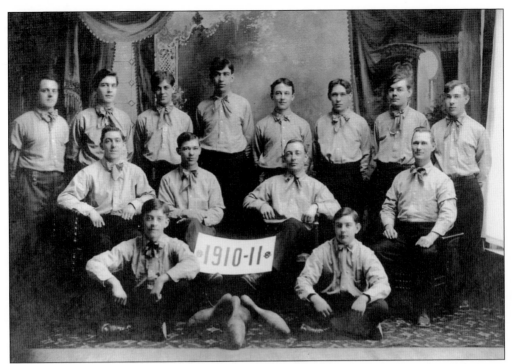

The members of this 1910–1911 Milwaukee bowling club wear team uniforms. The tradition at the time was to take photographs of the entire club, with pins and ball artistically arranged in front of the group. The wood floor implies they are facing the lanes, meaning this bowling alley had a rather ornate backdrop. (Courtesy of Milwaukee County Historical Society.)

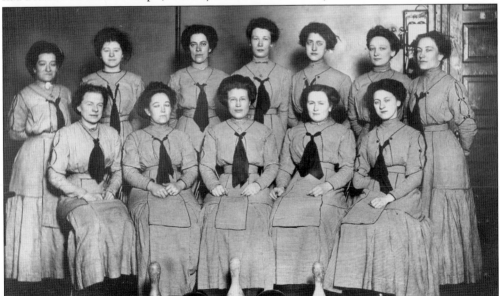

Women had their bowling clubs, too, even in the early days. Because they were not allowed in saloons, they had to enter the bowling alleys through an outside door. Women were only allowed, furthermore, to do so in the afternoons. It must have been difficult to throw the ball while covered from head to toe in those matching uniform dresses. (Courtesy of Milwaukee Public Library.)

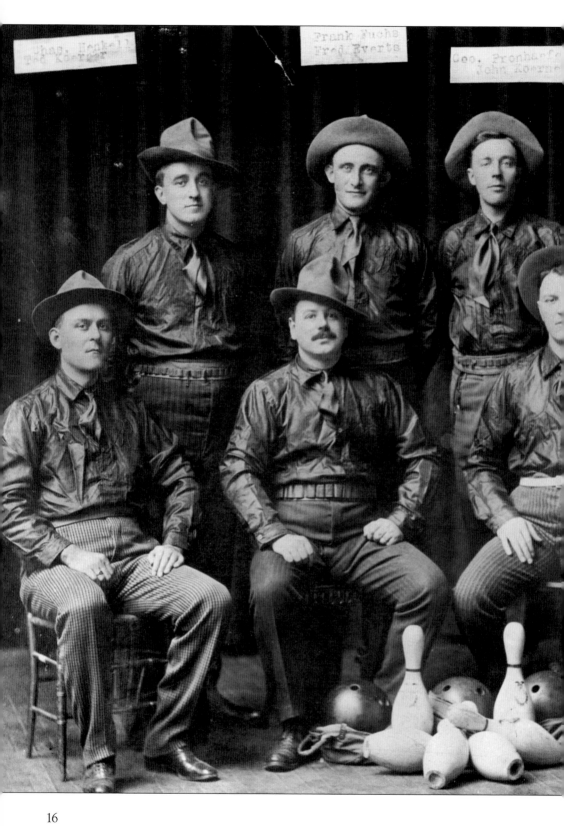

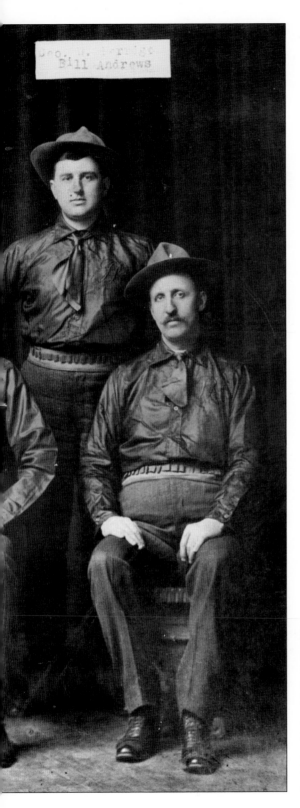

Known as the Rough Riders, this 1904 bowling club came complete with fedoras, bullet belts, and an attitude. Club members are, shown from left to right, (first row) Tad Koerner, Fred Everts, John Koerner, and Bill Andrews; (second row) Charley Henkell, Frank Fuchs, George Fronhaefer, and George W. Perrigo. Theodore Roosevelt, perhaps the most famous Rough Rider, was president at the time. (Courtesy of Milwaukee Public Library.)

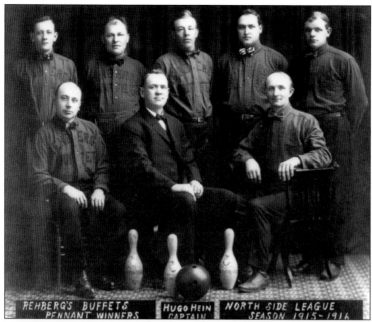

In addition to bowling clubs, private business owners began sponsoring teams. It was a terrific way to advertise the business as well as to build employee camaraderie outside of work. The Rehberg's Buffet team, pictured here, took first place in the North Side League 1915–1916 season. Team captain Hugo Hein is seated in the middle. (Courtesy of Milwaukee County Historical Society.)

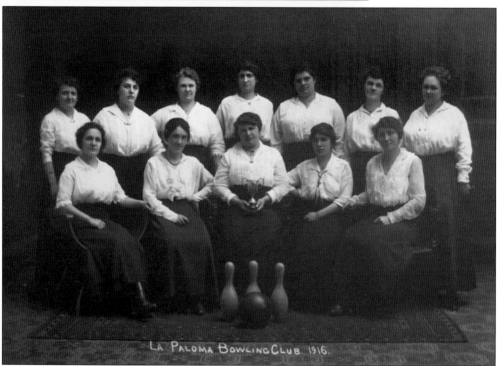

The La Paloma Bowling Club, shown here in 1916, was one of only a few women's clubs in that time period. Member Jean Knepprath was instrumental in bringing legitimacy to the sport of bowling for women, later becoming president of the Wisconsin Women's Bowling Association (WWBA) and, still later, the Women's International Bowling Congress (WIBC). The La Palomas first met weekly at Becker's Recreation Parlor, and later at Sonnenburg's on Third Street. (Courtesy of Milwaukee USBC Women's Bowling Association, Inc.)

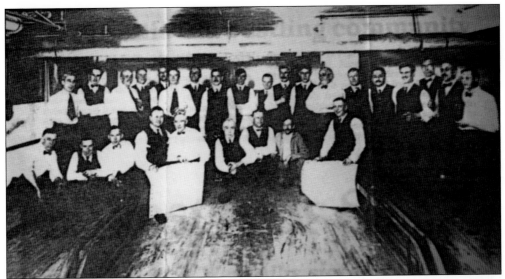

Bowling alleys can still be found in the basements of Milwaukee area churches and schools. These bowlers from West Allis pose for a *West Allis Star* photograph in the underground lanes of Holy Assumption School in 1916. Among them are West Allis mayor Frank Baldwin (standing third from left) and Theodore Trecker (standing fifth from right), founder of Kearney and Trecker. (Courtesy of Milwaukee USBC Women's Bowling Association, Inc.)

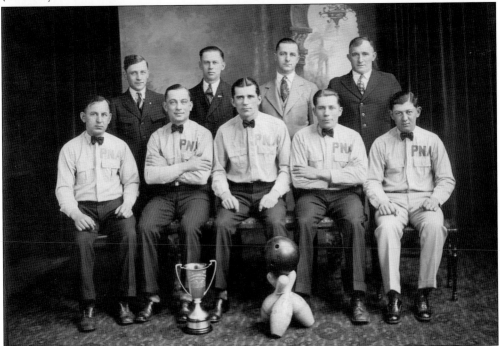

The Polish National Alliance (PNA) was founded in 1880 in Pennsylvania to provide humanitarian assistance to those of Polish descent in the United States and also to promote the independence of Poland. The organization had a strong presence in Milwaukee, sponsoring many bowlers throughout the years. This men's team poses with their trophy, won for the 1926–1927 season in Milwaukee. (Courtesy of University of Wisconsin-Milwaukee.)

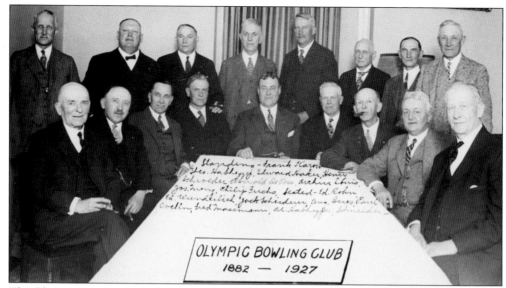

The Olympic Bowling Club was a subset of the Milwaukee Elks Club, meeting for nearly 50 years, beginning in 1882, to bowl and play skat, a card game popular with bowlers at the time. Club members shown above include Edward Rohn, Edward Wunderlich, Jack Schiederer, August Bues, Paul Coelln, Fred Massmann, Al Habhegger, a Mr. Schneider, Frank Karow, Theodore Habhegger, Edward Hahn, Henry Schroeder, Arnold DeVoss, Arthur Louis, Joseph Menz and Philip Fuchs. Below, longtime Olympic Bowling Club member Henry Schroeder fits his fingers into the hole of a bowling ball held by Joseph Menz, while Edward Haker looks on. (Both, courtesy of Milwaukee Public Library.)

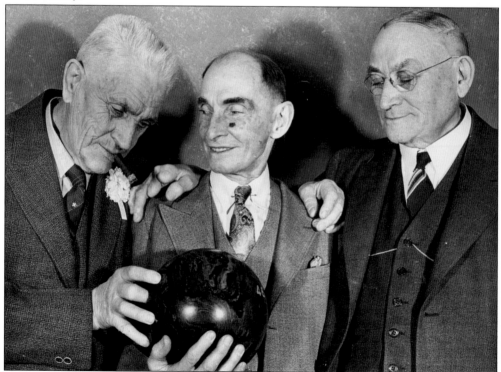

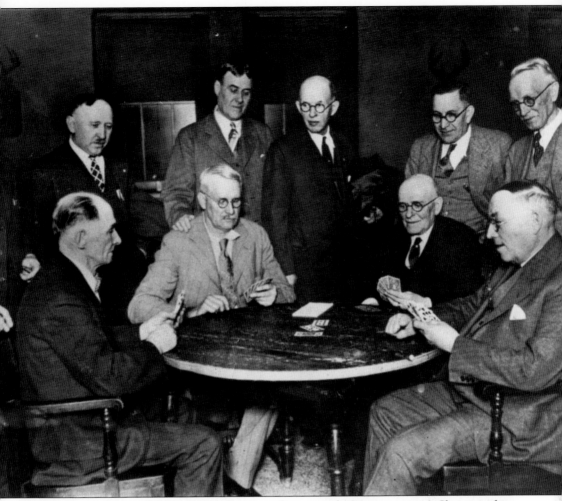

The Olympic Bowling Club is playing skat, a card game with German origins. Skat is said to have derived from the game *schafkopf* (sheepshead) in the 1800s and was a popular trick-taking game in Milwaukee beer gardens and bowling alleys. The game is still quite popular in Germany and other areas of the world today, with competitive international tournaments. The Elks Lodge, located at 910 East Wisconsin Avenue, was said to be one of the most spacious fraternal lodges in the country. The Northwestern Mutual Life Insurance Company headquarters now stands at the site. (Courtesy of Milwaukee Public Library.)

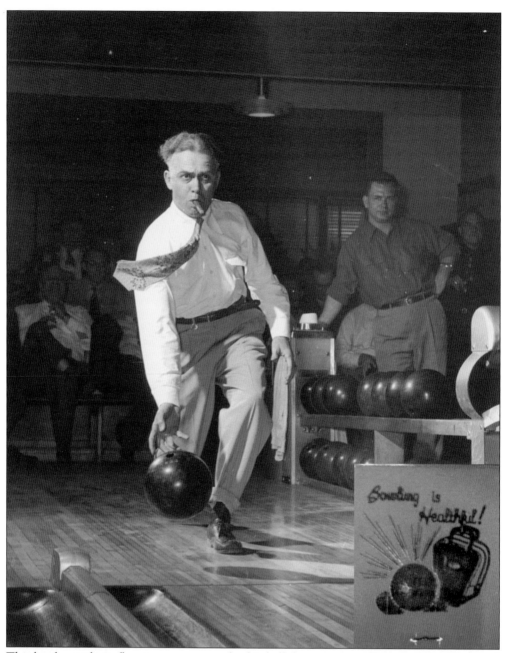

This bowler, with tie flapping, manages to lay his ball down pretty well, even with a king-sized stogie in his mouth. Since so many bowlers were smokers or tobacco chewers, ashtrays and spittoons were necessities in the lanes. The healthy exercise of bowling was trumpeted in advertisements such as the one on this pack of matches, but the ill effects of smoking were ignored. (Bowler photograph, courtesy of Milwaukee Public Library; inset, by Manya Kaczkowski.)

Two

ABC, WIBC, and America's Bowling Capital

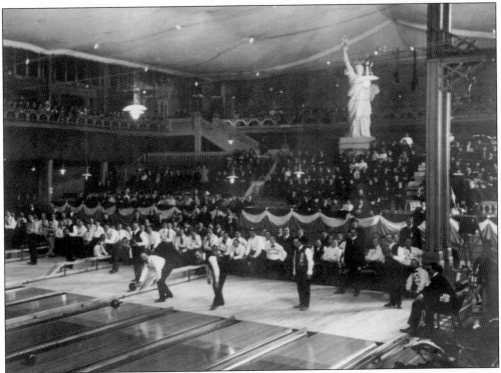

Inside the Exposition Building, a crowd of spectators watches the 1905 ABC tournament in Milwaukee. Galleries were set up on all sides to view the popular sport—even Lady Liberty got to watch. Note the foul judge, perched on the right, perpendicular to the lanes. It was a big year for Milwaukee and for bowling; the first rubber ball, called the Evertrue, was invented by Brunswick in 1905. Wood balls were prone to chipping on their way down the wood alleys and back, making consistency nearly impossible. (Courtesy of Wisconsin Historical Society.)

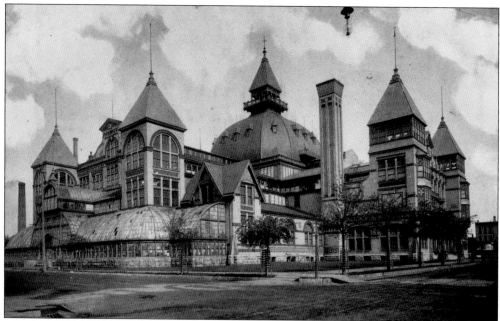

The Exposition Building was the location of the ABC tournament in Milwaukee on February 18, 1905. The enormous structure was located between Fifth, Sixth, Cedar (now Kilbourn), and State Streets. The building burned just four months later. Luckily, all historical exhibits from the Milwaukee Public Museum, which was initially housed in the Exposition Building, had been moved to the Milwaukee Public Library by 1898. (Photograph by S. L. Stein, courtesy of International Bowling Museum and Hall of Fame.)

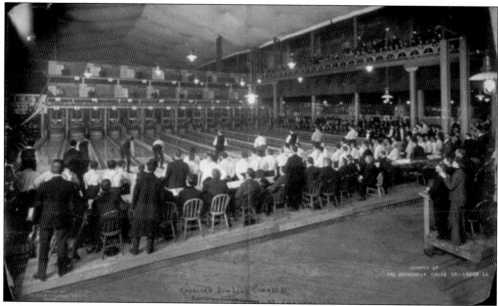

Thanks to the efforts of bowling alley proprietor Abe Langtry, this was the first of three times the ABC championship tournament was held in Cream City; the other years were 1923 and 1952. During the fire that destroyed the Exposition Building on June 4, 1905, the canvas cloth seen in this photograph burst into flames during a national skat tournament. (Courtesy of Doug Schmidt.)

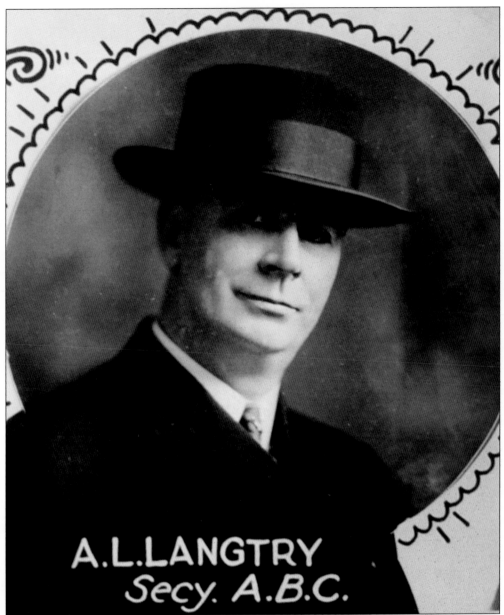

A.L.LANGTRY
Secy. A.B.C.

Abe Langtry, an early Milwaukee proprietor, opened 24 lanes in downtown Milwaukee in the 1890s at Second Street and Wisconsin Avenue. He was instrumental in bringing the ABC tournament to Milwaukee in 1905. The success of this event, along with Langtry's election as secretary of the ABC two years later, brought the organization to town and helped turn Milwaukee into "America's Bowling Capital." Langtry ran the ABC for the next 25 years until 1932, when he supported holding the national tournament in Detroit instead of Milwaukee against the wishes of the Milwaukee Bowling Association (MBA). Unable to withstand the backlash from members of the MBA, Langtry endured a mental breakdown and lost his position with the ABC. (Courtesy of International Bowling Museum and Hall of Fame.)

The WIBC was formed in 1916 after the ABC took a vote and refused to allow women to join their membership ranks. This Milwaukee team attended the 1918 WIBC national tournament in Cincinnati, held in conjunction with the ABC national tournament. Shown from left to right are (first row) Amanda Oldenberg (substituting for her mother, C. Rogahn, who had a broken arm), Helen Blau (first president of the Milwaukee Women's Bowling Association (MWBA)), and Ann Hirsch; (second row) Elizabeth Pasbrig (secretary of the MWBA), Caroline Rogahn, and an unidentified woman. The ABC poster overhead provides a touch of irony to the scene. (Courtesy of Milwaukee USBC Women's Bowling Association, Inc.)

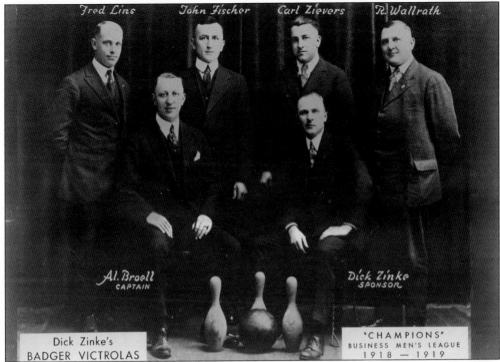

The Milwaukee Badger Victrolas team posed for a picture with their sponsor Dick Zinke in 1919, the year they won the championship for their Business Men's League. Pictured from left to right are (first row) captain Al Broell and team sponsor Dick Zinke; (second row) Fred Lins, John Fischer, Carl Zievers, and R. Wallrath. (Courtesy of Doug Schmidt.)

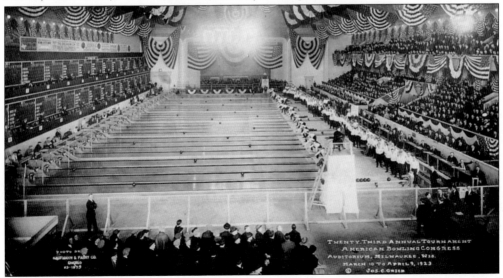

This postcard by Joseph C. Grieb gives an inkling of the pomp and circumstance that surrounded the ABC annual tournaments in the 1920s. This was the second for Milwaukee, held at the Auditorium in 1923. The Auditorium was constructed in 1909 on the same site as the former Exposition Building. Note the collection of pin boys, each waiting to reset the sticks at the end of an alley. (Courtesy of Doug Schmidt.)

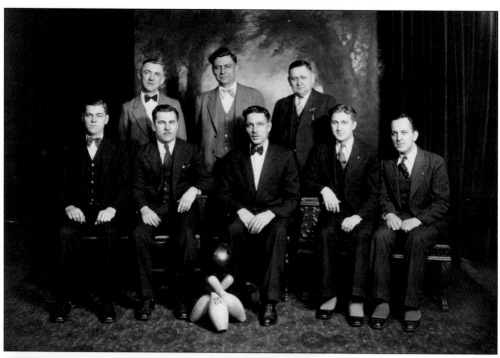

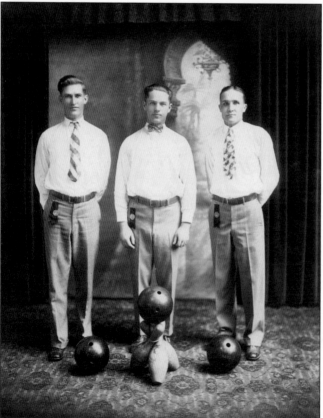

The officers of the Polish American Bowling Association posed for this photograph above in the late 1920s. Among them are Dr. J. J. Kazmierowski (seated third from left), John Kotlarek (seated second from right), treasurer John A. Schultz (standing second from left), and president John Ludka Jr. (standing far right). (Courtesy of University of Wisconsin-Milwaukee.)

These young fellows are the Grevsmuehl Drugs team, and they've just won the bronze medals they're wearing during the three-men league at Graff's Alleys, at the South Side intersection of Thirty-second and Scott Streets. The year was 1927, and their collective average was 676. (Courtesy of University of Wisconsin-Milwaukee.)

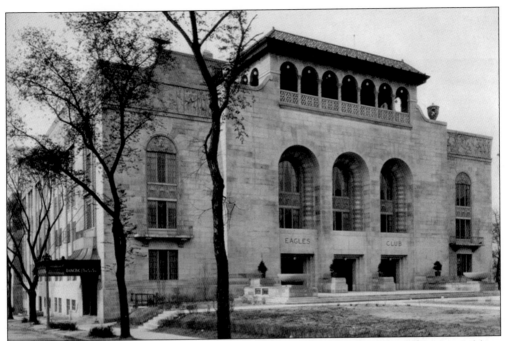

Fraternal organizations and athletic clubs (such as the Elks, Wisconsin Club, and Milwaukee Athletic Club) were huge proponents of the sport of bowling in Milwaukee, many going so far as to install lanes in their own buildings. The home of the Eagles Club, established in 1926, was an elegant example of 1920s Revival architecture. This Milwaukee "aerie" for the Fraternal Order of Eagles was a massive meeting and entertainment complex. (Courtesy of The Rave/Eagles Club.)

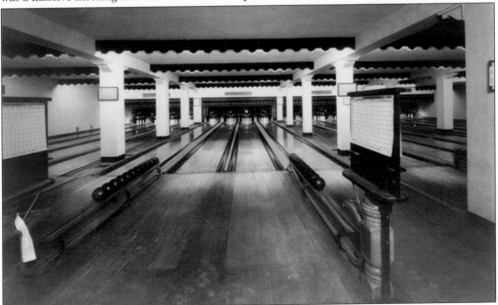

There were 16 alleys gracing the basement of the Eagles Club. Bowling was a regular part of the sports entertainment enjoyed by members of the Fraternal Order of Eagles. The lanes were unfortunately removed in 1985 to make room for Eagles Hall, one of several concert venues in the building. (Courtesy of The Rave/Eagles Club.)

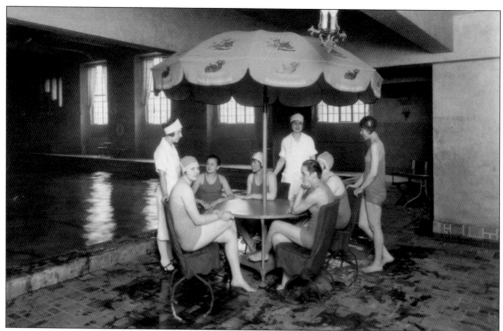

A group of loungers from the 1920s enjoys some relaxation after a swim in the enormous pool at the Eagles Club. Located on Grand Avenue (later renamed Wisconsin Avenue), the Eagles Club was renamed The Rave/Eagles Club in the 1980s. It remains a venue for national concert acts, with six entertainment stages. (Courtesy of The Rave/Eagles Club.)

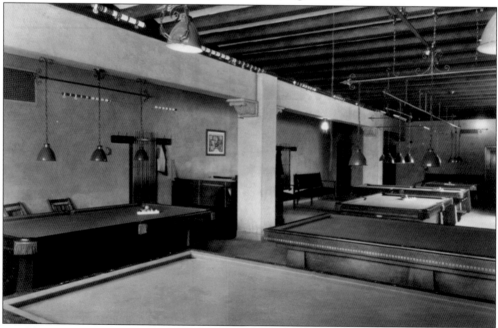

In addition to the bowling alleys and swimming pool, the Eagles Club featured a billiards room (pictured), a boxing ring, a stage for live theater and concerts, and a dance hall. The fleur-de-lis lamp holders above the pool tables provided an elegant touch for a pool hall. (Courtesy of The Rave/Eagles Club.)

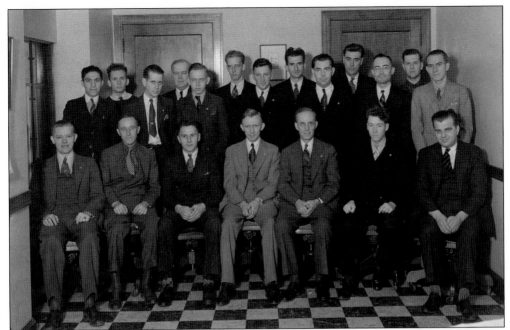

As shown in this photograph from 1938, the need for employees at the ABC had grown substantially. At this point, the offices were still located in downtown Milwaukee. After Langtry's resignation, the new secretary, Elmer Baumgarten, moved to Milwaukee from Chicago, keeping the Milwaukee staff on board. (Courtesy of International Bowling Museum and Hall of Fame.)

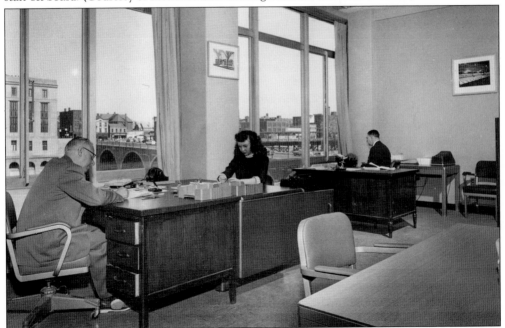

The ABC offices were open and spacious, with commanding views of the city. The only machine in sight is an old-fashioned adding machine on the far wall. The picture above it appears to be the interior of the Exposition Building, all set up for the 1905 tournament. (Courtesy of International Bowling Museum and Hall of Fame.)

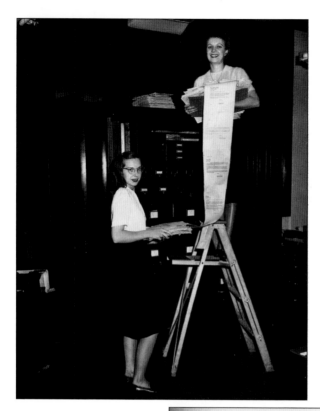

There was plenty of filing and bookkeeping to do at the ABC. Here office employees Trudine Ann John and Gertrude Fridl have their hands full. At the height of ABC membership, there were some 4.8 million members. (Courtesy of International Bowling Museum and Hall of Fame.)

Before a bowler's technique is perfected, it is necessary to understand bowling rules and etiquette. *Bowling,* ABC's official publication, occasionally published helpful resources for bowlers related to good behavior on the lanes. (Courtesy of the International Bowling Museum and Hall of Fame.)

Bowling Etiquette Comes First

1. Remain back of the foul line at all times.
2. Control your temper and refrain from abusive language.
3. When a bowler on an adjoining lane is addressing the pins, respect his priority. Do not step in front of him to pick your ball off the rack.
4. If you and another bowler are ready to bowl at the same time, give him the first privilege unless he signals you to go first.
5. Confine your "body-English" to your own alley. Don't jump or wander over to the next lane.
6. Don't waste time. After your ball hits the pins, walk in a straight line to the back of the approach.
7. Don't kid your opponent when he is addressing the pins.
8. Be a good sport at all times. Give credit where credit is due. Remember, it takes a real sport to be a good loser.
9. Splits, misses and taps are just as much a part of bowling as strikes and spares. Don't blame your faults on equipment. Rather, determine what you are doing wrong and try to correct your faults.

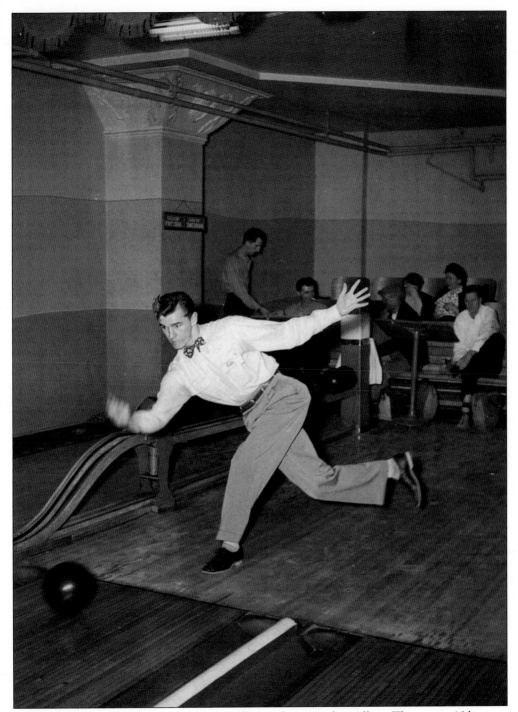

Ed Wojciechowski shows great style as he rolls a strike at Antlers Alleys. There were 16 lanes at the Antlers, and they were popular with league bowlers. Opened in 1925, the Antlers lanes were used until 1950 for a total of 25 years; the hotel survived until 1981, when it was demolished to make room for the Grand Avenue Mall. (Photograph by Edmund Eisenscher, courtesy of Wisconsin Historical Society.)

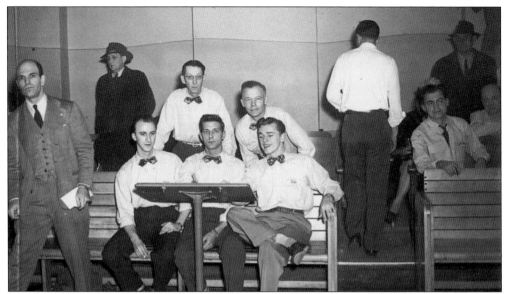

Antler's Alleys, located in the basement of Hotel Antlers at Second Street and Michigan Avenue, was where the Cushions bowling team ruled the UAW Local 75 league in 1946. Out of 54 games, they lost only four that season, with an average team score of 832. Shown from left to right are (first row) Bill Doll, Mike Nowak, and Ed Wojciechowski; (second row) Art Schuenke and captain Ray Behrens. (Photograph by Edmund Eisenscher, courtesy of Wisconsin Historical Society.)

The ABC excluded not only women but also non-white males from their membership until 1951. Prior to that, only one bowling alley in Milwaukee allowed black leagues to play—Johnny Geldon's South Side Arcade on Twelfth Street and Lincoln Avenue—and then only on Sundays. Isaiah Pyant, shown here, was a member of the Bronzeville Bombers. The team bowled in the Bronzeville Classic League at Johnny Geldon's. (Photograph by Edmund Eisenscher, courtesy of Wisconsin Historical Society.)

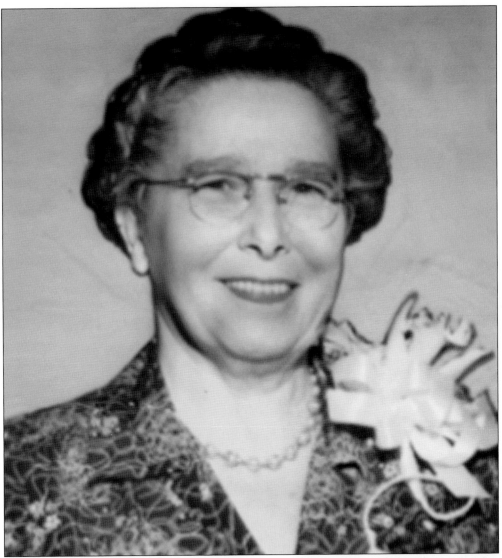

In 1916, in an age when bowling was considered a man's sport, Jean Knepprath became a member of one of Milwaukee's earliest women's teams, the La Palomas. She served 46 years as secretary of the WWBA, while also serving as president of first the Woman's National Bowling Association (WNBA), then the WIBC, for 36 years. Although her reign could at times be controversial, there is no question that she was committed to (and successful at) publicizing the sport for women on a national basis. Knepprath ran both the local and national women's bowling organizations out of her home in Milwaukee and was not afraid to stand up for issues she felt were instrumental to the success of each organization, even if it meant temporary alienation of those who disagreed with her. Her tenacity was well appreciated in the end; organizations honoring her with service awards included the Bowling Institute of America, the MWBA Hall of Fame, the WIBC Hall of Fame, and the WWBA Hall of Fame. (Courtesy of International Bowling Museum and Hall of Fame.)

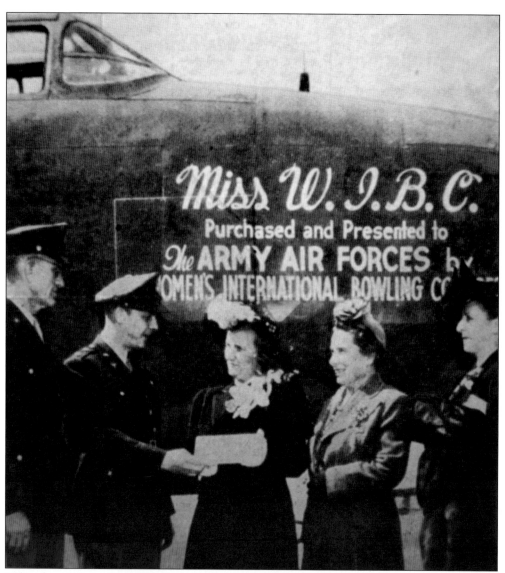

Milwaukee women—and all WIBC members—proved they could do more than just bowl. In 1943, Jean Knepprath spearheaded an effort that resulted in the WIBC raising $100,000 to purchase a Douglas A-20 bomber for the military, named, affectionately, *Miss W.I.B.C.* Throughout the war, WIBC raised enough money for the purchase of an ambulance and three more airplanes—Douglas C-47 evacuation models at $80,000 apiece. The program was termed "Wings of Mercy." Pictured from left to right in this AP photograph are Brig. Gen. Ray G. Harris, Maj. Stanford Chester, Violet McClatchery, Jean Knepprath, and Ruby Clear. (Courtesy of Milwaukee USBC Women's Bowling Association, Inc.)

The fun-loving members of the Milwaukee chapter of the WIBC were known for trips and outings in connection with tournament events. After the 1956 WIBC tournament in Miami, this group of women, which included some Milwaukeeans, took a side trip to Havana, Cuba. That year, the annual tournament drew 1,915 five-women teams. (Courtesy of Milwaukee USBC Women's Bowling Association, Inc.)

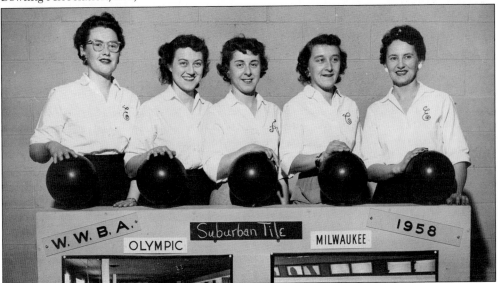

In 1958, the WWBA annual tournament was held in Milwaukee at Olympic Recreation Lanes, whose 24 alleys had opened the year before in 1959. Bowlers of this cheery team, sponsored by Suburban Tile, are, from left to right, unidentified, Dorothy Krause, Audrey Stark, Grace Bohl, and Elaine Gulch. (Courtesy of Sandy Stark.)

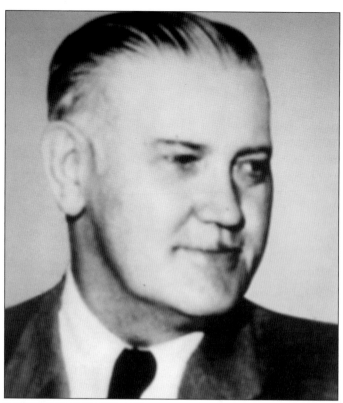

Eli Whitney, pictured here, was hired in 1940 to be the ABC's first public relations director. In that role, he began the ABC newsletter, served as editor of *Bowling,* and initiated the ABC Hall of Fame. (Courtesy of International Bowling Museum and Hall of Fame.)

Bowling made its debut in the 1940s and lasted 60-odd years into the 21st century. In addition to stories on individual bowlers, teams, and the goings-on related to various tournaments and trends in the industry, each issue featured one or more cartoons. (Courtesy of International Bowling Museum and Hall of Fame.)

"You don't love me any more . . . criticising my hook—"

Glueck certainly had a funny bone; his cartoons managed to find humor in the very seriousness that bowlers brought to the game. Often, his drawings poked fun at the rules, the intense competition between bowlers, or the lengths bowlers went to in order to improve their game. Hence the bowler above whose captain gave him "homework," meaning lots of practice. Through Glueck's cartoons, readers of *Bowling* were treated on a monthly basis to the lighter side of the sport. (Courtesy of International Bowling Museum and Hall of Fame.)

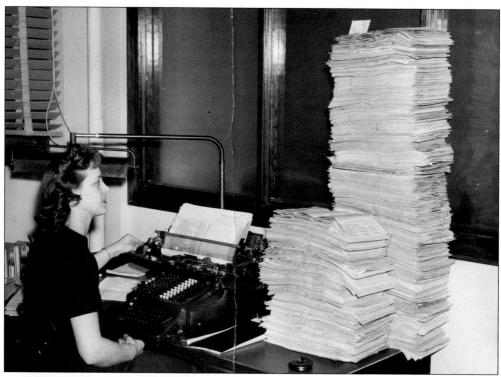

By the middle of the 20th century, ABC membership had grown substantially to more than a million members, fueled by returning World War II soldiers. Dorothy Kozmatka, bookkeeper with the ABC, had quite a stack of scorecards to process into team standings in those precomputer days. (Courtesy of International Bowling Museum and Hall of Fame.)

This 1956 scorecard from the Milwaukee Bowling Association is a reminder of the importance of a league secretary. In those days, scores were added by hand on the lanes, re-added by the secretary, and then compiled into weekly, then seasonal, statistics. (Courtesy of University of Wisconsin-Milwaukee.)

They've Planned Big Things For You At Milwaukee!

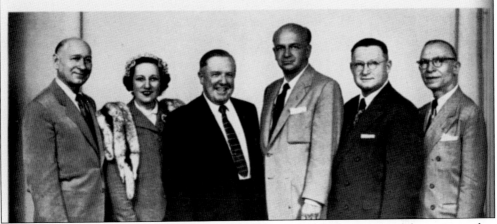

This is the Wisconsin Bowling Proprietors Association (WBPA) committee that put together arrangements for the 1955 Bowling Proprietors Association of America (BPAA) convention, held in Milwaukee. Shown from left to right are Roy Otto, Isabel Kress, Jim Zimmerman, Les Strachota, Fred Kress, and Hank Marino. (Courtesy of International Bowling Museum and Hall of Fame.)

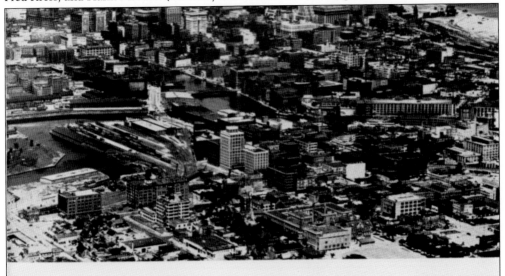

MILWAUKEE—A Big League Town

To get proprietors across the nation excited about the upcoming BPAA convention, *Bowling Proprietor* magazine published an article about the wealth of entertainment opportunities in the city, including the new arena, County Stadium (home of the Milwaukee Braves), and Gimbels department store. This picture of Milwaukee's downtown accompanied the article. (Courtesy of International Bowling Museum and Hall of Fame.)

This *Bowling Proprietor* ad for the Hotel Schroeder was put out prior to the BPAA convention in June 1955. The hotel, an art deco masterpiece with an expansive ballroom, was designed by architectural firm Holabird and Roche for hotel and insurance entrepreneur Walter Schroeder. It was his signature hotel and his most ambitious project, a 25-story landmark on the corner of Fifth Street and Wisconsin Avenue. Today the hotel is the Hilton Milwaukee City Center, renovated in the 1990s to its original splendor and enhanced with the addition of an indoor water park. The BPAA convention included many planned activities, including luncheons, sightseeing, and a dinner-dance. (Courtesy of the International Bowling Museum and Hall of Fame.)

This coach demonstrates bowling techniques to a group of students in a Milwaukee bowling alley, sometime around the middle of the 20th century. Individual bowling centers have always provided instruction, especially to juniors. Today the USBC also operates a state-of-the-art training facility with 14 training lanes, video analysis from robotic cameras, foot and grip pressure mapping, and visual eye tracking for professional bowlers. A staff of coaches and a fitness center round out the possibilities at the International Training and Research Center in Arlington, Texas. Time marches on. (Photograph by Fred R. Stanger, courtesy of Wisconsin Historical Society.)

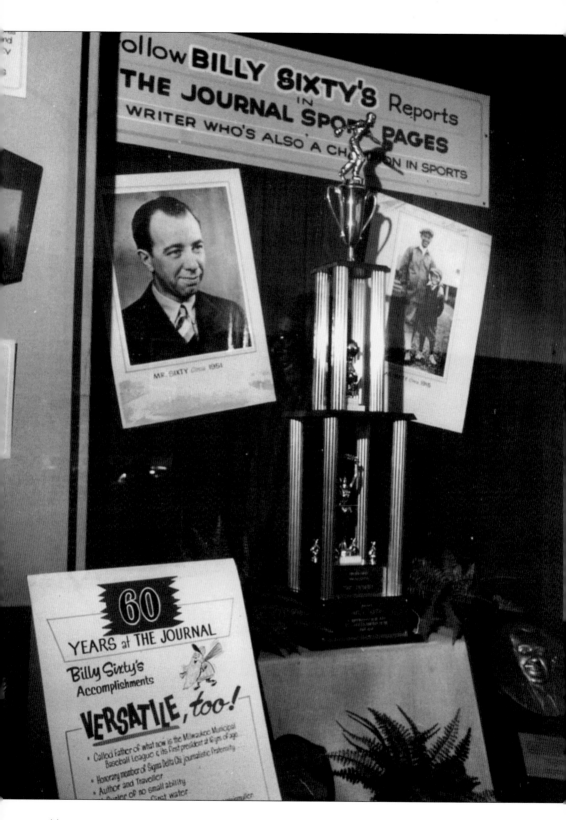

Billy Sixty was a Milwaukee institution. As a respectable amateur golfer he made nine holes in one. As a bowler, he racked up nine 300 games—even though his debut into the ABC tournament scene began with three gutter balls and a score of 74. His next two games made up for it with scores of 194 and 227. Sixty was a member of the Heil Products team during its heyday in the 1930s and a member of the championship Knudten Paint team in the 1940s. But he was best known for his contributions to the sport of bowling as a writer. For six decades, Billy Sixty, who began his journalism career with a job as copy boy at the *Milwaukee Journal* when he was just 12 years old, was a sports writer for the *Milwaukee Journal* and a frequent contributor to *Bowling* magazine. Sixty was elected to the ABC (now USBC) Hall of Fame in 1961. In this *Milwaukee Journal* image by Sherman Gessert, he stands before some of his own personal memorabilia. (Courtesy of Milwaukee County Historical Society.)

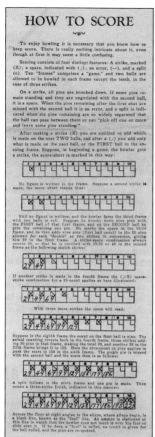

HOW TO SCORE

To enjoy bowling it is necessary that you know how to keep score. There is really nothing intricate about it, even though at first it may seem a little confusing.

Scoring consists of four distinct features: A strike, marked (X); a spare, indicated with (/); an error, (—), and a split (o). Ten "frames" comprises a "game," and two balls are allowed to be bowled in each frame except the tenth, in the case of three strikes.

On a strike, all pins are knocked down. If some pins remain standing and they are negotiated with the second ball, it is a spare. When the pins remaining after the first shot are missed with the second ball it is an error, and a split is indicated when the pins remaining are so widely separated that the ball can pass between them or can "pick off one or more and leave some pins standing."

After making a strike (X) you are entitled to add which is made on the next TWO balls, and after a (/) you add only what is made on the next ball, or the FIRST ball in the ensuing frame. Suppose, in beginning a game, the bowler gets a strike, the score-sheet is marked in this way:

No figure is written in the frame. Suppose a second strike is made, the score sheet stands thus:

Still no figure is written, and the bowler faces the third frame with two balls to roll. Suppose he knocks down nine pins with the FIRST ball of that first frame, and on the SECOND ball he gets the remaining one pin. He makes the spare in the third frame, and he then adds nine pins (first ball count) to the 20 pins allowed for each "double" or two strikes in succession, giving him 29 in the first frame. A strike-spare combination always counts 20, so that he is credited with 29-20 or 49 in the second frame as the following sketch shows:

If another strike is made in the fourth frame the (/-X) spare-strike combination for a 20-count applies as here illustrated:

With three more strikes the score will read:

Suppose in the eighth frame the count on the first ball is nine. The actual counting reverts back to the fourth frame, three strikes adding 30 pins in that frame, making the total 79, and another 30 in the fifth frame brings it to 128. Here the nine-count on pins applies to push the score to 158 in the sixth frame. The single pin is missed with the second ball and the score then is as follows:

A split follows in the ninth frame and one pin is made. Then comes a three-strike finish, indicated in this manner:

Across the floor at right angles to the alleys, where alleys begin, is a black line, known as the "foul" line. An umpire is stationed at this line to watch that the bowler does not touch it with his foot as he slides over it. If he does, a "foul" is called, no credit is given for the ball rolled, and the pins are re-spotted.

With today's automatic scorekeeping and electronic screens showing a bowler exactly where to throw the ball to pick up a spare, it is easy to forget the essential elements of the game of bowling. Billy Sixty gave instruction, through his writing, on the rudiments: scorekeeping, finding the mark for a strike, and making spares—even difficult ones. Not only did he capture important moments in the sports, he also served as a role model to those wanting to truly understand bowling— whether that meant rules, techniques, champion bowlers, or the essence of competitions. Although the accomplished sports writer was commonly known as Billy Sixty, his last name was actually Soechtig ("sixty" in Dutch). He later had the name legally changed to Sixty. These drawings were first presented by Sixty in the *Milwaukee Journal* as a special insert. (Courtesy of Milwaukee County Historical Society.)

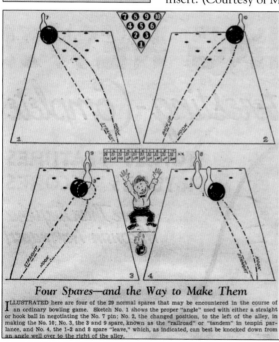

Four Spares—and the Way to Make Them

ILLUSTRATED here are four of the 29 normal spares that may be encountered in the course of an ordinary bowling game. Sketch No. 1 shows the proper "angle" used with either a straight or hook ball in negotiating the No. 7 pin; No. 2, the changed position, to the left of the alley, in making the No. 10; No. 3, the 3 and 9 spare, known as the "railroad" or "tandem" in tenpin parlance, and No. 4, the 1-2 and 8 spare "leave," which, as indicated, can best be knocked down from an angle well over to the right of the alley.

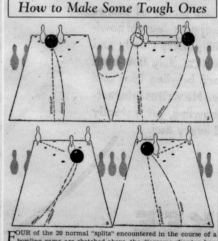

How to Make Some Tough Ones

FOUR of the 20 normal "splits" encountered in the course of a bowling game are sketched above, the diagrams showing how they may be negotiated with either a straight or hook ball. In making the Nos. 4-5 pins (Sketch 1) it is necessary to fit the ball between them. The approximate "angle" or position from which the ball should be started on the alley is indicated by the dotted lines. The Nos. 4-6-7-10 (Sketch 2) is made by sliding either the No. 4 or the No. 6 across the alley; the Nos. 3-7-10 (Sketch 3) requires the ball to be fitted between the 3-10, the No. 3 skidding across the alley to clip the No. 7, and the Nos. 2-7-10 (Sketch 4) is negotiated from the opposite or right side as illustrated.

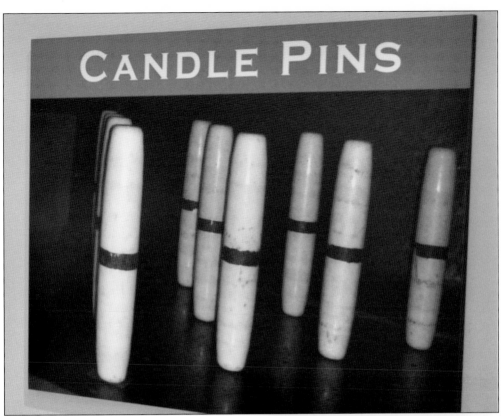

CANDLE PINS

In Milwaukee, there's more than one way to bowl. Candlepins (above) began to be used in the United States in 1880 when partners Justin White, Jack Monsey, and Jack Sheafe from Worchester, Massachusetts, began standardizing pin size and manufacturing them for other proprietors. Duckpins (at right) have a murkier history; the origin has been reported as Baltimore, Massachusetts, and as Boston, Mississippi. Either way, they were in use sometime around the end of the 19th century and can still be played in Milwaukee at Koz's Mini-Bowl on Seventh and Becher Streets. (Both photographs by Manya Kaczkowski, courtesy of International Bowling Museum and Hall of Fame.)

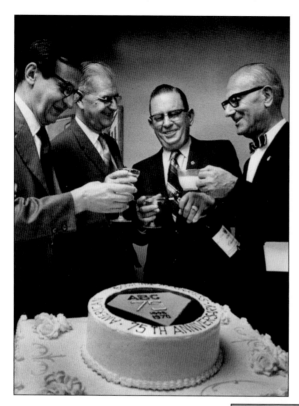

The year 1970 was exciting for the ABC—it was their 75th anniversary, and the Federation Internationale des Quilleurs had just been scheduled to take place at the Milwaukee Arena the following August, catapulting Milwaukee into the international bowling scene. Shown celebrating the anniversary from left to right are assistant secretary Al Matzelle, executive secretary Frank Baker, president Conn O. Wilson, and 75th anniversary committee chairman John Martino. (Courtesy of Milwaukee County Historical Society.)

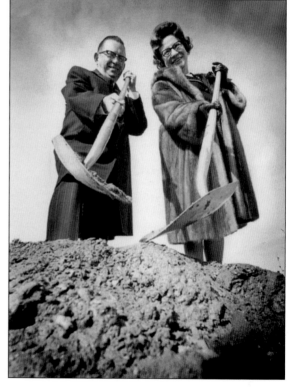

In 1972, the ABC and the WIBC moved to their combined headquarters building on South Seventy-sixth Street in Milwaukee. Here ABC president Conn O. Wilson and WIBC president Alberta Crowe are breaking ground for the $2.5 million complex. Although the ABC had only to move across town, WIBC employees—and all of their files—moved to Milwaukee from Columbus, Ohio. (Courtesy of Milwaukee County Historical Society.)

Roger Dalkin is a member of the USBC Hall of Fame. He started in Milwaukee as manager of the ABC/WIBC Collegiate Division and worked his way up to become executive director of the ABC. He was then instrumental in creating a successful merger of the ABC, WIBC, and Young American Bowling Alliance (YABA) under the new name of United States Bowling Congress. (Courtesy of International Bowling Museum and Hall of Fame.)

It was a sad day for Milwaukee when the USBC packed up and moved to Arlington, Texas, to merge with the BPAA in 2008. Although Milwaukee made a pitch to create a new facility in town, they were unsuccessful. In Arlington, the merger resulted in a large complex that houses the USBC, the BPAA, and the USBC's International Training and Research Center. In 2010, the International Bowling Museum and Hall of Fame was added, and the former museum in St. Louis was closed. (Photograph by Manya Kaczkowski.)

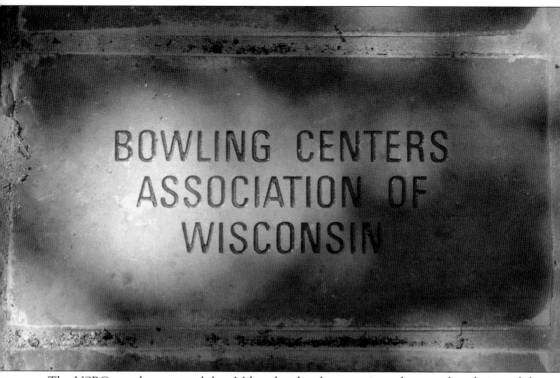

The USBC may have moved, but Milwaukee has been set into the very foundation of the new complex in Arlington. This brick from the Bowling Centers Association of Wisconsin is embedded into the front walk. Several employees relocated from Milwaukee to Arlington with the organization's move, and the museum and archives are full of Milwaukee history. (Photograph by Manya Kaczkowski.)

Three

MILWAUKEE'S MOST POPULAR PASTIME

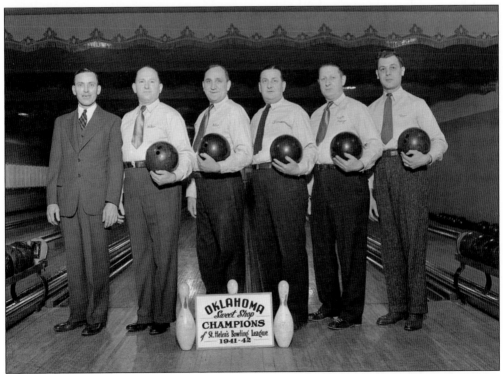

This victory must have been sweet for the Oklahoma Sweet Shop champions. Bowling was such an integral part of Milwaukee culture that even religious organizations got rolling. Churches in Milwaukee often had bowling leagues, and St. Helen's, a Catholic church on Milwaukee's South Side, was no exception. The five-man Sweet Shop team took first place in the St. Helen's 1941–1942 season. (Photograph by Dennis Wierzba, courtesy of University of Wisconsin-Milwaukee.)

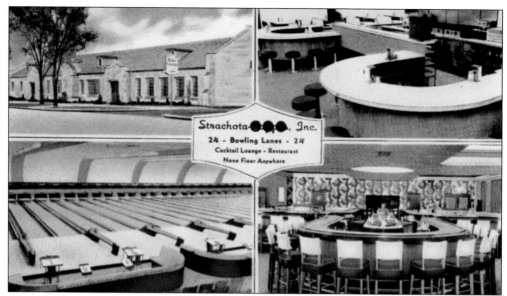

Completed in 1948 by brothers Les, Andy, and Reuben Strachota, the Milshore Bowl was the epitome of modernism. Their 24 lanes were the site for national BPAA tournaments and also for the new Masters Traveling League. Dave Strachota became a second-generation owner, buying the lanes back after they were sold in the 1970s due to the untimely deaths of his father and uncles. The Strachotas also owned and operated Strachota's Regent Recreation at Fortieth Street and North Avenue, home of the Les Strachota Individual Sweepstakes—Wisconsin's largest individual sweepstakes in the 1940s. Anyone could bowl in the tournament, no matter what the average, although it is amusing to note that the category with no restriction on average cost bowlers more cash to enter. (Above, courtesy of Milwaukee Public Library; below, courtesy of International Museum of Bowling and Hall of Fame.)

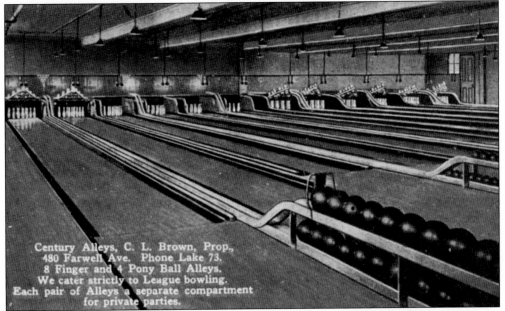

Century Alleys on Farwell Avenue dated back to 1925 and featured four shorter pony ball lanes (third through sixth lanes from the left), plus eight standard-size equipment lanes. The bowling alley stayed open until 1960, then turned into a bar and concert hall before burning to the ground in 1988. Today a restaurant and shopping mall are located on the site. (Courtesy of Milwaukee Public Library.)

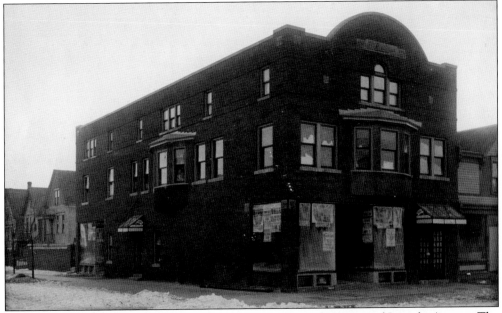

Badura Tavern was built by Frank Badura in 1912 on Eleventh Street and Lincoln Avenue. The lanes were installed in the basement several years later, and the place was a popular South Side bowling alley for many years. This is not to be confused with Badura's Tap and Bowling Lanes, which was located at Thirtieth Street and Lincoln Avenue in the 1950s. (Photograph by Roman Kwasniewski, courtesy of University of Wisconsin-Milwaukee.)

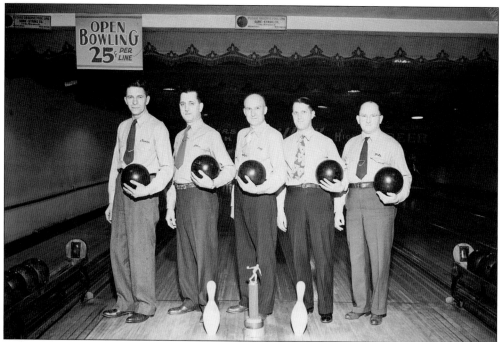

Here is another trophy-winning team in a Milwaukee alley from the 1940s. Open bowling at these lanes was a mere 25¢ per game. Note the strict warnings above the lanes to stay behind the foul lines; judges still performed their critical function during league play at the time. (Photograph by Dennis Wierzba, courtesy of University of Wisconsin-Milwaukee.)

Milwaukee's Heil Company sponsored many teams over the years, including The Truck Tanks. They played in the Heil Local 1344 Social League in 1947. Pictured from left to right are Ray Werra, Tony Lidwin (captain), George Karolowski, Ben Schwacher, and Emil Dostrzewa. (Photograph by Edmund Eisenscher, courtesy of Wisconsin Historical Society.)

In March 1947, this team took part in the Milwaukee County Bowling Tournament. Shown from left to right are Chester Chojnacki, Louis Mersho, Carl Schlinke (captain), Earl Gielow, and Milt Tieman. All were members of the CIO Electrical Workers Local 1131 Winders team. (Photograph by Edmund Eisenscher, courtesy of Wisconsin Historical Society.)

Shown in 1947 is the Heil Water Systems bowling team. They bowled at Antlers Alleys underneath Hotel Antlers in downtown Milwaukee. Pictured from left to right are Rolamel Schmidt, Jack Burns (captain), Leo Huscia, Leo Slowik, and Joe Strong. (Photograph by Edmund Eisenscher, courtesy of Wisconsin Historical Society.)

THE 300 GAME

It takes "something extra" to bowl a 300 game . . . a perfect coordination of eye and muscle, a solid knowledge of the sport, a special quality of calmness that won't "blow" in those final, tense frames. Yes, it takes a mighty good bowler to enter that charmed 300 circle.

We think it takes "something extra" to brew the fine quality beers which have made Milwaukee the brewing center of the world, too. It takes craftsmen who are wholly devoted to the ancient traditions of brewing . . . who are more interested in making the finest beer than in making the biggest profit . . . who care more for their reputation than their ease . . . who are proud of their heritage and have the courage to protect it.

These are the men. But there's more to the story.

It takes well built, well kept alleys, perfect pins perfectly spotted, the finest of equipment to give that bowler his 300 game.

And it takes spotless kettles and tanks, modern scientific controls, the finest of ingredients to brew Milwaukee's beers.

One thing more is essential. To bowl 300 or to brew quality beer takes Integrity . . . on the part of the bowler and the bowling alley proprietor . . . on the part of the brewing craftsman and the brewery management.

For your National Convention, we wish you a 300 for every game and Milwaukee beer for every Fifth Frame!

●

MILWAUKEE BREWERS' ASSOCIATION

Fox Head Brewing Company
A. Gettelman Brewing Company
Independent Milwaukee Brewery

Miller Brewing Company
Pabst Brewing Company
Jos. Schlitz Brewing Company

The Milwaukee Brewers' Association (makers of beer, not baseball) was quite interested in bowling, to which beer was a perfect accompaniment. Each local brewery sponsored teams, advertised in industry magazines, and took pains to keep bowlers happy and drinking their brand. In preparation for the 1955 BPAA convention that was heading toward Milwaukee, the Brewers' Association placed this "300 Game" ad in the *Bowling Proprietor* magazine to welcome the BPAA, many of whom were expert bowlers themselves. It is interesting to note that Blatz is missing from the list—this was around the beginning of their financial struggles, although they didn't shut down operations until 1959, when they sold their label to Pabst. (Courtesy of International Bowling Museum and Hall of Fame.)

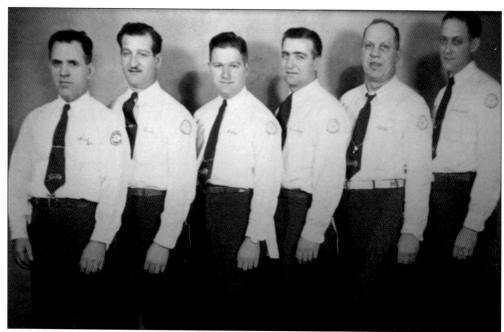

After Prohibition ended, beer could once again be consumed legally during bowling. Milwaukee brewers began recruiting talented keglers to join their company-sponsored team, like this group of athletes, each sporting a Schlitz tie. (Courtesy of International Bowling Museum and Hall of Fame.)

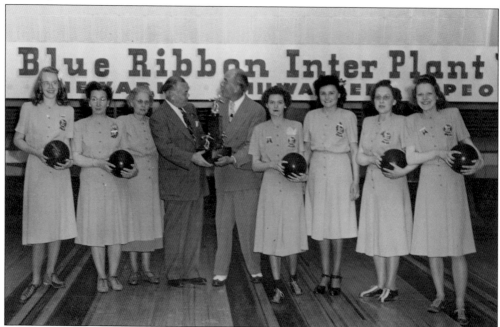

The Pabst Blue Ribbon women's team from Milwaukee won the Inter Plant championship in 1957 with a total of 2,258 points. They faced Pabst teams from Chicago, Peoria, and Newark in the event. The Pabst men's team from Milwaukee took their division, too, with a total score of 2,672. (Courtesy of International Bowling Museum and Hall of Fame.)

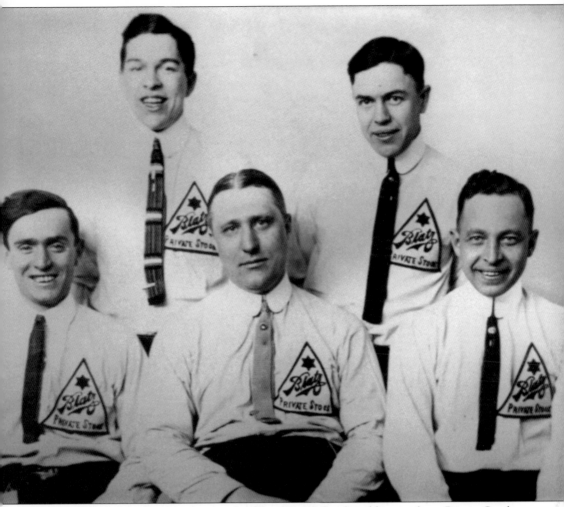

These gents are wearing bowling shirts with a Blatz Private Stock emblem on them. Private Stock was made as early as 1914—one newspaper advertisement said that it was a "home drink for every member of the family." That was certainly true during Prohibition, when Private Stock was made with no alcohol content. Blatz, like its Milwaukee competitors, sponsored teams across the country. The hexagram shown on the men's Blatz emblems is a six-pointed star, or *bierstern* (beer star) used by the brewers' guild in southern Germany as early as the 1500s. There is no known connection between the bierstern and the similar Jewish Star of David. (Courtesy of International Bowling Museum and Hall of Fame.)

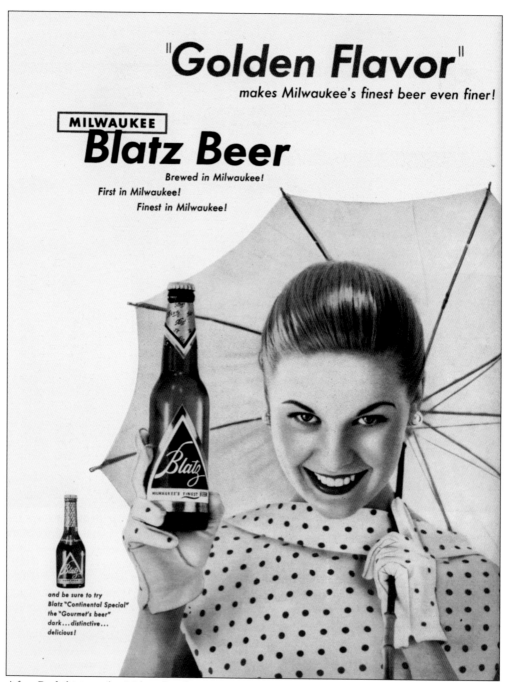

"**Golden Flavor**"

makes Milwaukee's finest beer even finer!

MILWAUKEE
Blatz Beer

Brewed in Milwaukee!

First in Milwaukee!

Finest in Milwaukee!

and be sure to try
Blatz "Continental Special"
the "Gourmet's beer"
dark...distinctive...
delicious!

After Prohibition, the Milwaukee brewers were free once again to make as much beer as they could sell, and companies like Blatz, Schlitz, Pabst, and Miller took full advantage of the bowlers market. This ad ran in a 1955 issue of *Bowling Proprietor* magazine. It is apparent that it was geared toward the upcoming BPAA convention in Milwaukee. What is interesting is that there's nothing about bowling in the ad at all. Male bowlers were likely attracted to a beautiful girl holding a beer, and female bowlers were encouraged to drink Blatz, since the woman in the ad was holding one. (Courtesy of International Bowling Museum and Hall of Fame.)

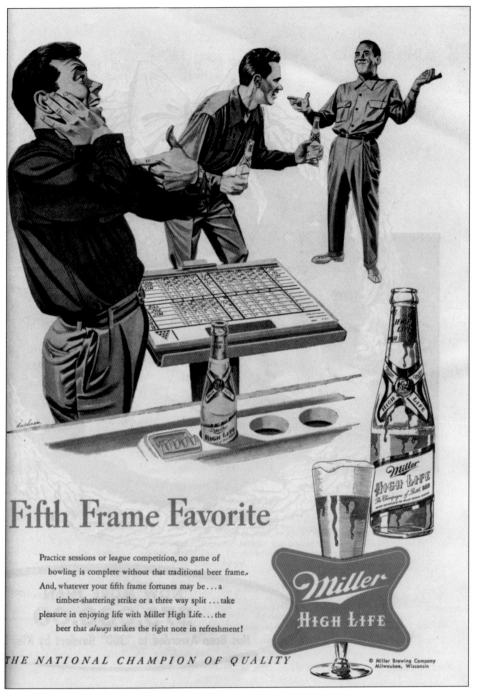

Fifth Frame Favorite

Practice sessions or league competition, no game of
bowling is complete without that traditional beer frame.
And, whatever your fifth frame fortunes may be...a
timber-shattering strike or a three way split...take
pleasure in enjoying life with Miller High Life...the
beer that *always* strikes the right note in refreshment!

THE NATIONAL CHAMPION OF QUALITY

Miller
HIGH LIFE

© Miller Brewing Company
Milwaukee, Wisconsin

Tradition says the lowest-scoring bowler in the fifth frame buys the next round of beers. This 1954
Bowling ad by Miller Brewing implies that the next round should be Miller High Life. This ad was
truly geared toward bowlers, with language like "the beer that always strikes the right note" and
the "national champion of quality." Also interesting is the fact that on the score sheet the fifth
frame is outlined in darker ink than the rest of the frames. It looks like the bowler on the left is
buying. (Courtesy of International Bowling Museum and Hall of Fame.)

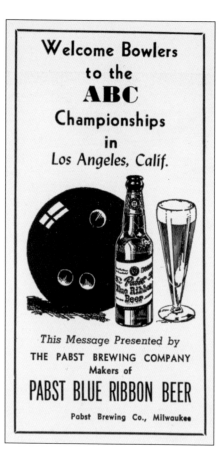

Welcome Bowlers
to the
ABC
Championships
in
Los Angeles, Calif.

This Message Presented by
THE PABST BREWING COMPANY
Makers of
PABST BLUE RIBBON BEER

Pabst Brewing Co., Milwaukee

Pabst was also in the advertising game when it came to bowlers. This highly targeted *Bowling* ad gives a Milwaukee welcome to competitors heading off to the 1947 ABC championship tournament in Los Angeles. It was the first time the tournament had ever been held west of Kansas City, and Pabst wanted to make sure its beer was a favorite. (Courtesy of International Bowling Museum and Hall of Fame.)

Even Kessler, the "smooth as silk" whiskey, found a place among bowlers. This mid-century bowling guide and record book could be found in Milwaukee bowling alleys and served as the perfect advertisement to league members. Published in 1957, it's a 32-page guide with plenty of tips for bowlers, plus a place to record tournament scores. All while sipping whiskey, of course! (Brochure courtesy of Milwaukee County Historical Society.)

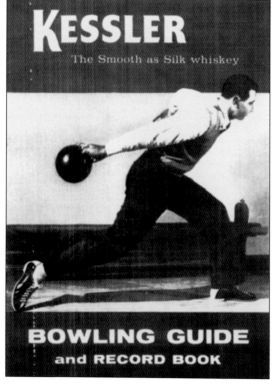

KESSLER
The Smooth as Silk whiskey

BOWLING GUIDE
and **RECORD BOOK**

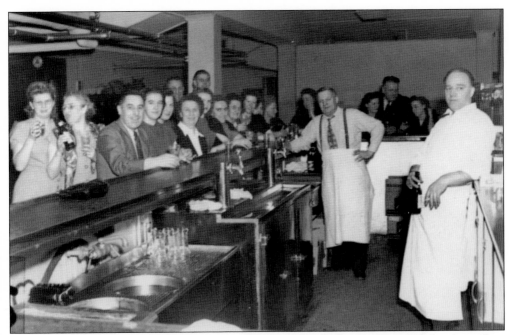

Having refreshments was a part of bowling night for many Milwaukeeans. The bowling alleys under the Lutheran Center in Milwaukee brought customers into the bar before and after the games to socialize and share a few laughs. This picture dates back to 1948. (Photograph by Edmund Eisenscher, courtesy of Wisconsin Historical Society.)

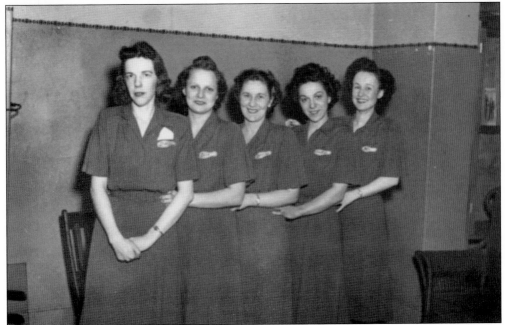

The Lauftenberg Brothers Company women's bowling team was rolling at the Lutheran Center bowling alleys on Eleventh and State Streets in 1948. Their poses, as well as the names on their dresses (Tracy, Bee, Bonnie, Smitty, and Pat), provide a refreshing glimpse of nostalgia. (Photograph by Edmund Eisenscher, courtesy of Wisconsin Historical Society.)

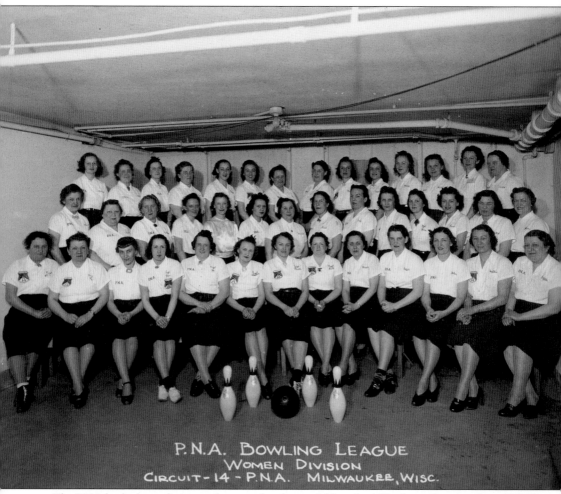

P.N.A. BOWLING LEAGUE
WOMEN DIVISION
CIRCUIT - 14 - P.N.A. MILWAUKEE, WISC.

The PNA had a large division of women bowlers in Milwaukee. Uniformed and well coiffed, the women teams were usually forced to bowl in the afternoons in those early days, since men took up their leagues at night. These days, the PNA still hosts bowling tournaments (and lots of other events) in various locations around the country. An annual Polish Fraternal Bowling Tournament takes place each year with teams from the Polish Falcons, the Polish Women's Alliance, and the Polish Roman Catholic Union. (Courtesy of University of Wisconsin-Milwaukee.)

These *Milwaukee Journal* photographs show that the 1937 city tournament gave women a chance to let loose a little, sans men. Besides bowling, much socializing (and a little smoking and drinking) took place at Bensinger's West, which also hosted the WIBC 1942 national tournament as the nation went to war and WIBC celebrated its 25th anniversary. There were 1,900 teams (676 from Milwaukee) at the event that year bowling on a mere 15 lanes—a WIBC record. Hundreds of flowers were presented at the opening ceremonies of that silver jubilee tournament, and Milwaukee's mayor, Carl Zeidler, made a speech to the thousands of women in attendance. Below, Hazel Klein makes her move on the left, while Marie Zimbehl peers down the lanes at her victims. Note the veil on Zimbehl—apparently bowling was no reason not to dress up. (Courtesy of Milwaukee USBC Women's Bowling Association, Inc.)

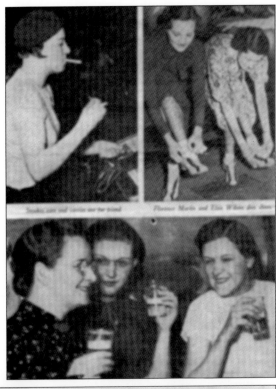

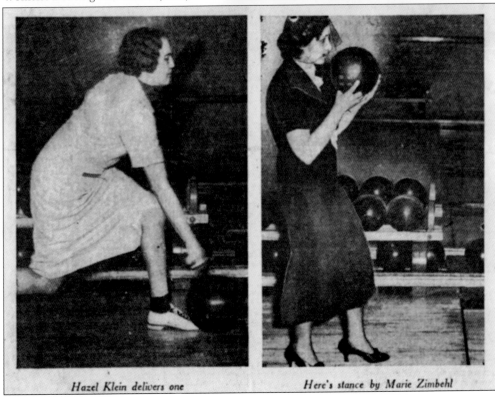

Hazel Klein delivers one

Here's stance by Marie Zimbehl

The alleys at the Moose Lodge on Jefferson Street in downtown Milwaukee were hosts to the Union Local 75 women's league in 1947. From left to right in the first row are the Moose Boosters: Ann Chomicki, Betty Kreutzfeldt, Lillian Laver, Bernadine Lemanczyk, and Betty Bittner (captain). From left to right in the second row are the Bright Spots: Emma Barrs (captain), Helen Janotta, Helen Zeromski, Isabelle Wrosch, and Pearl Czerniak. (Photograph by Edmund Eisenscher, courtesy of Wisconsin Historical Society.)

Another UAW Local 75 women's team from 1947 was known as the Seaman Body Company. Shown from left to right are Myrtle Rohloff, Hilda Lange, Tillie Stowasser, and two unidentified team members. Over the years, Local 75 has sponsored many bowling teams in various lanes across the city. Those sponsorships tapered off in the 1990s due to plant closings and retirements. (Photograph by Edmund Eisenscher, courtesy of Wisconsin Historical Society.)

Now these girls could really rise to the occasion. The Wonder Bread team is getting ready to roll in an alley in Elm Grove—note the clock behind them. This image shows that times have advanced a bit—even the ball returns look space-age modern. (Courtesy of Wisconsin Historical Society.)

Which of these gals is not like the other? Four of them are sisters, and all five bowled together for at least 20 years—for 16 years under the sponsorship of Advance Tool and Die Company. The team average was 794, and they won three league championships. From left to right are Gertrude Lederer, Lillian Speckter, and Louise, Adeline, and Eleanor Lederer, featured in *Woman Bowler* magazine. (Courtesy of Milwaukee USBC Women's Bowling Association, Inc.)

Bowling is an activity that everyone in the family can enjoy. In this *Milwaukee Journal* photograph, Theodore Weiss and his daughter Janet play pinsetter on Dads Day at Milwaukee-Downer College. Milwaukee-Downer College was a women's college whose campus consisted of several buildings (Merrill, Holton, and Greene Hall among them) and a residence hall. In 1964, Milwaukee-Downer College merged with Lawrence University in Appleton and sold its Milwaukee Campus to University of Wisconsin-Milwaukee (UWM). The original bowling alley didn't survive, but UWM opened its own 10-lane bowling alley and billiards room in the lower level of the student union in 1972, where it remains today. UWM students can even take a class in the theory and practice of bowling. (Courtesy of Wisconsin Historical Society.)

Before the half-century mark, a group of blind athletes took to the lanes in this *Milwaukee Journal* photograph. Conquering sports was the norm for this group; they had already mastered baseball, swimming, and golf. Jess Borman is about the throw the ball, while Ann Speck (center) and Maxine Bellon wait their turn. (Courtesy of Milwaukee USBC Women's Bowling Association, Inc.)

In 1947, the West Allis Bowling Center at Seventy-second Street and Greenfield Avenue hosted a league of disabled veterans on Tuesday afternoons, thanks to bowling alley manager Paul Herzbrun, a World War II vet, and his father-in-law, Dr. J. E. Frankel, the lanes' owner. Bowling and refreshments were on the house. Here Norman Kirch (left) and Johnny Mateju make their shots, with John Rausch (behind, left) and John Tomich assisting. (Courtesy of International Bowling Museum and Hall of Fame.)

The Forest Home Arcade knew how to honor Polish ladies. This contest celebrated Polish Day in 1931 by selecting the most popular *dama* (lady) in town. There was no shortage of Polish bowlers at Schultz's Forest Home Arcade. Some of the bowlers from the arcade's 12-team league of 1935 were Kozlowski, Rydzewski, Szewczuga, Czerwinski, Kocziusko, Sadowski, Ryczek, Orlowski, and Kaminski. (Courtesy of University of Wisconsin-Milwaukee.)

The *Let's Go Bowling on TV* show was devised and aired in Milwaukee in 1955, the same year as the popular and long-running *Bowling With the Champs*. *Let's Go Bowling on TV*, sponsored by the Milwaukee Bowling Proprietors Association and Miller High Life, featured a contest tournament with prizes each week for bowlers who had qualified in their own Milwaukee bowling alleys prior to the show. *Bowling Proprietor* covered the show's debut. (Courtesy of International Bowling Museum and Hall of Fame.)

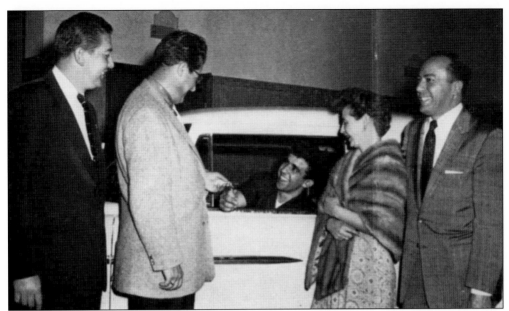

Let's Go Bowling on TV awarded prizes each week: bicycles, bowling balls, bags, and cash. But the grand prizes, a 1955 Plymouth Plaza Club Sedan for the men's division and a silver blue mink stole for the women's, were won during a roll-off competition in the last episode. Shown in this *Bowling Proprietor* photograph from left to right are B. A. Strachota (city sales manager for Miller Brewing), Wally Rank (president of Rank and Sons Plymouth, which donated the car), Tom Curro (men's division winner), Elaine Jensen (women's division winner), and Art Littman (the Milwaukee furrier who donated the stole). (Courtesy of International Bowling Museum and Hall of Fame.)

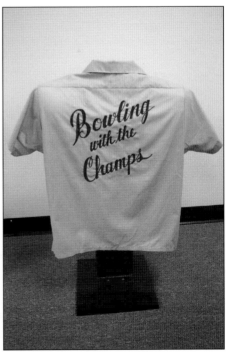

Bowling With the Champs first matched national champions with top local players selected by sports journalist Billy Sixty, then later changed its format to feature Wisconsin bowlers only. There were nominal cash prizes, but anyone who rolled a 300 game received a car. The show was filmed at a different alley each week for the first three years, then settled in for multiyear stints at American Serb Hall, the Eagles Club, and finally, Red Carpet Bolero, where it finished out its 41-year run. This shirt from the show now rests in the International Bowling Museum and Hall of Fame in Arlington, Texas. (Photograph by Manya Kaczkowski.)

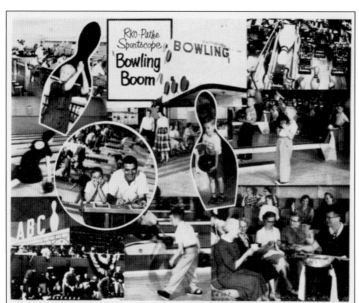

Above are some scenes from the new RKO-PATHE Sportscope movie "Bowling Boom" (see July-August issue) featuring the increase in popularity of the nation's top participant sport. It is estimated that 30 million people will see it. Contact your local theaters and urge them to schedule the film and then help publicize it. Sequences showing high school and college students attending regular classes in bowling are included in the film; also, shots of industrial, church, housewife and bantam leagues as well as elderly people filling happy hours with this healthful sport.

At the 1955 BPAA Convention in Milwaukee, the film *Bowling Boom* was shown to proprietors, who were advised to make arrangements with local theaters to show the film in an effort to increase interest in the sport. This *Bowling Proprietor* ad shows scenes featuring happy bowlers, from children to octogenarians. The film was produced by RKO Films and Paramount Pictures as a short to be shown prior to a feature film. (Courtesy of International Bowling Museum and Hall of Fame.)

The Lithographers Intercity League celebrated the end of the 1948 bowling season with a dinner dance. This snappy duo appears to be a Chicago/Milwaukee blend; her tag says "ALA 'Windy' Ill 48" and his tag boasts "ALA 'Beerwaukee' Wisc 48." The location of the event is unknown, but the banner on the stage shows the music was provided by the Rythmeers. (Photograph by Edmund Eisenscher, courtesy of Wisconsin Historical Society.)

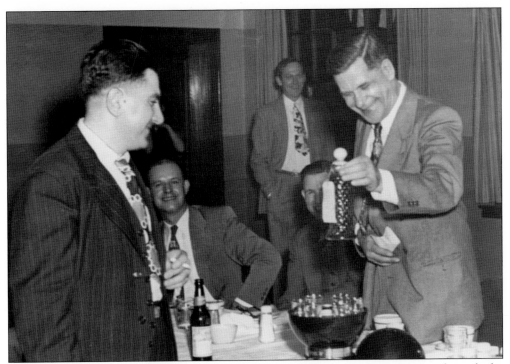

At the Lithographers intercity bowling dinner dance, a liquor trophy is presented to a lucky recipient. Shaped like a bowling ball, it appears to hold a variety of enticing beverages. (Photograph by Edmund Eisenscher, courtesy of Wisconsin Historical Society.)

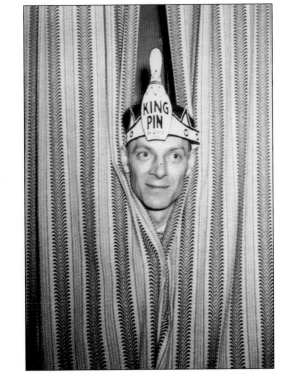

The Lithographers Intercity League members seem to have elected quite an interesting ruler for the season. This "King Pin" watches the activities as he peers through a set of curtains at the 1948 bowling dinner dance. (Photograph by Edmund Eisenscher, courtesy of Wisconsin Historical Society.)

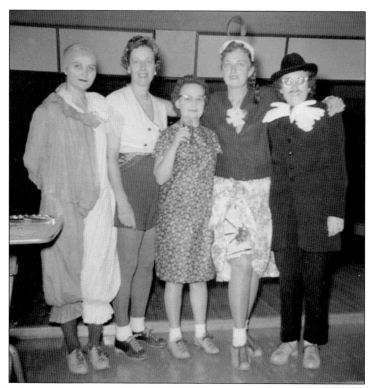

These ladies from the Gieringer Florist team tapped into their inner dress-up divas on Halloween during the 1959–1960 season at Echo Bowl on Port Washington Road. Echo Bowl unfortunately closed its doors in 2004 after a 47-year run. (Courtesy of Milwaukee USBC Women's Bowling Association, Inc.)

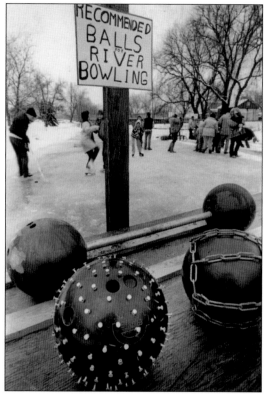

This is truly alternative bowling. It gets cold in Wisconsin, but some folks still want to bowl outside. This benefit for disabled children in Menomonee Falls took place during the 1980s, but "ice bowling" remains a popular nonprofessional sport, particularly at winter festivals. Occasionally, instead of bowling balls, frozen turkeys are hurled at the pins. (Courtesy of Milwaukee County Historical Society.)

Four

LOCAL CHAMPIONS

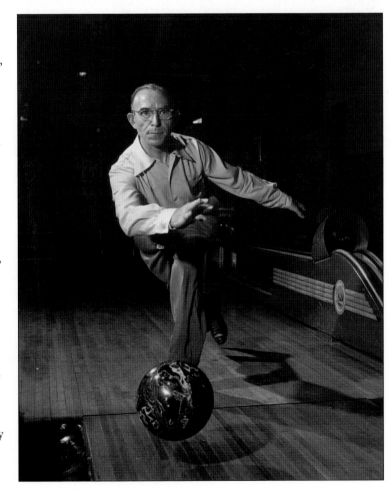

When Enrico "Hank" Marino finally retired to Santa Monica in 1964, he had racked up more bowling statistics and accomplishments than any other Milwaukee bowler. He spent the first few years of his American life in Chicago, becoming a barber, then a bowler, then a bowling alley proprietor. But from 1930 until 1964, Hank Marino did Milwaukee proud as bowling alley proprietor and champion bowler. He is seen here aiming a ball down the alley at his own Marino Recreation. (Courtesy of International Bowling Museum and Hall of Fame.)

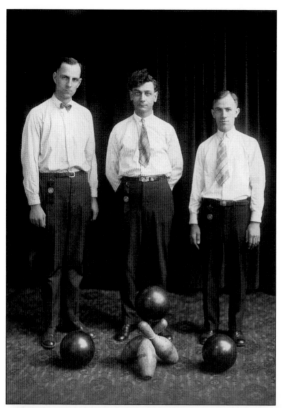

There are many ways to be considered a champion bowler—through seasonal leagues, in local and regional tournaments, by rolling a 300 game or an 800 series, or by winning in the national bowling scene. At Graff's Alleys, competition in the Three-Men League was fierce. These three gents from Simon Drugs were the gold medal champions in the 1924–1925 league, with a score of 716. (Courtesy of University of Wisconsin-Milwaukee.)

These members of the Milwaukee Polish Association of America were the 1927 Polish Inter-Fraternal Bowling League champions. Pictured with their trophy from left to right are (first row) J. Sobolewski, T. Budny, M. Bessa, William Rudzinski, J. Kleszczynski, and M. Barczak; (second row) J. A. Schultz, J. Lemanski, R. D. Pankowski, J. J. Ludka Jr., "a Mr. Bykowski," J. J. Kotlarek, and Z. Kaminski. (Courtesy of University of Wisconsin-Milwaukee.)

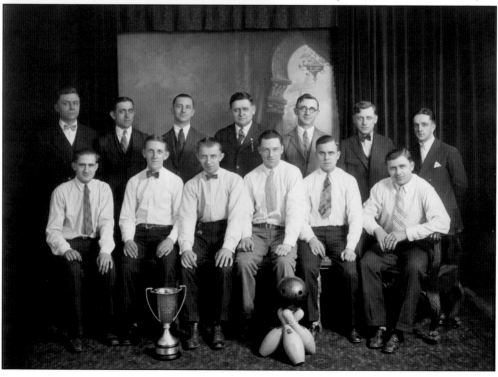

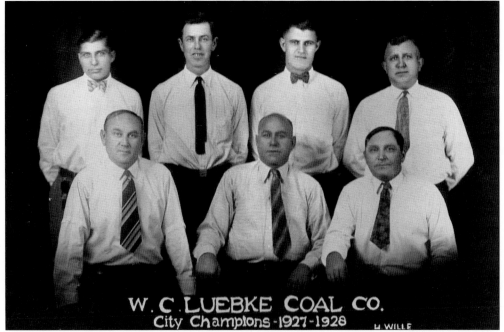

The W. C. Luebke Coal Company teammates were the proud city champions during the 1927–1928 season. Pictured from left to right are (first row) C. Knuth, M. Luebke, and J. Schmeltzer; (second row) Herb Arndt, C. Prey, A. Rubow, and H. Wille. Arndt later joined the Cudahy Fuels, a powerhouse team from just south of Milwaukee. (Courtesy of Doug Schmidt.)

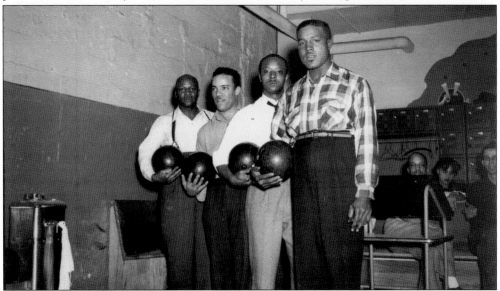

The Bronzeville All-Star bowling team from 1946 is shown here after placing at the CIO tournament. The All-Stars' regular bowling establishment was Johnny Geldon's—the only bowling alley to allow blacks to bowl at that time. Bronzeville was a thriving African American neighborhood in Milwaukee centered around Walnut Street. Sadly, the neighborhood was dissected in the late 1960s when a freeway was constructed. (Photograph by Edmund Eisenscher, courtesy of Wisconsin Historical Society.)

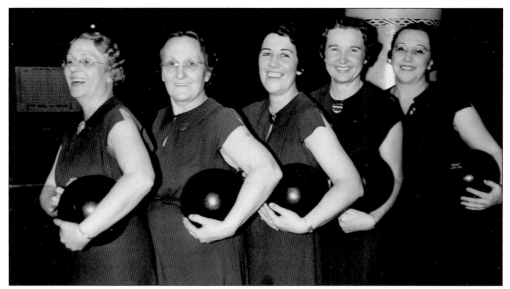

These ladies were double trouble on the lanes—during the 1937–1938 season, their Braumeister team took second place in Marino's Wednesday night league and first place at the Plankinton Arcade on Thursday nights. Pictured from left to right are A. Rusha, L. Vrieth, L. Carroll, E. Mannebach, and M. Clasen. (Courtesy of Milwaukee USBC Women's Bowling Association, Inc.)

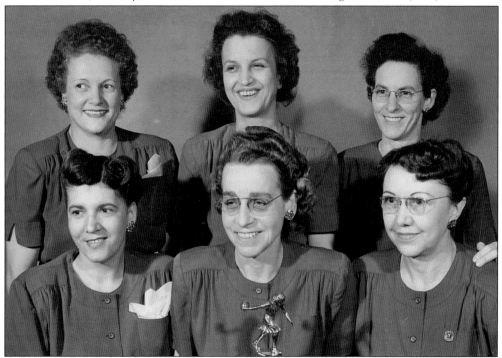

It was a banner day for the Club Pointe bowlers, who took the championship in the Wisconsin-Marino league in 1948, beating their rivals, the Korchnoffs. Pictured from left to right are (first row) Rosalie Novak, Gladys Shields, and Maurine Clasen (then president of the MWBA); (second row) Helen Foster, Nell Schutta, and Bert Page. Schutta rolled a 687 series in the league, the highest in the state that year. (Courtesy of Milwaukee USBC Women's Bowling Association, Inc.)

Local champs came in junior sizes, too. In the year 1965, the American Junior Bowling Congress presented awards to the winners of the senior title at Airport Bowl on Second Street. Shown from left to right in the *Milwaukee Journal* with their trophies are Dale Pinkowski (14), Bob Davis (17), Calvin Schultz (16), Don Gaszak (15), and Tom Berg (15). (Courtesy of Milwaukee USBC Women's Bowling Association, Inc.)

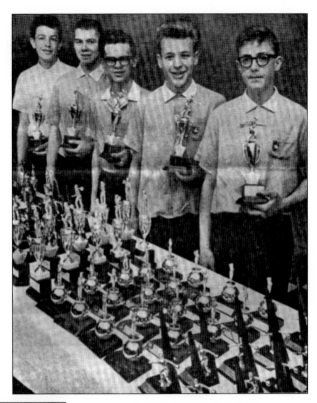

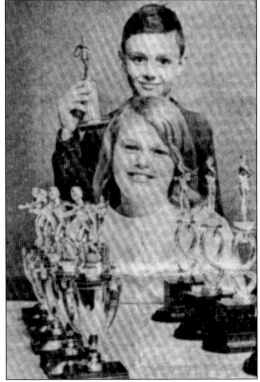

Charlie Krocker, 9, and Sue Garden, 11, paired up in the junior mixed doubles event at the American Junior Bowling Congress meet in 1965. The *Milwaukee Journal* reported a winning two-day game total of 689 for the pair. (Courtesy of Milwaukee USBC Women's Bowling Association, Inc.)

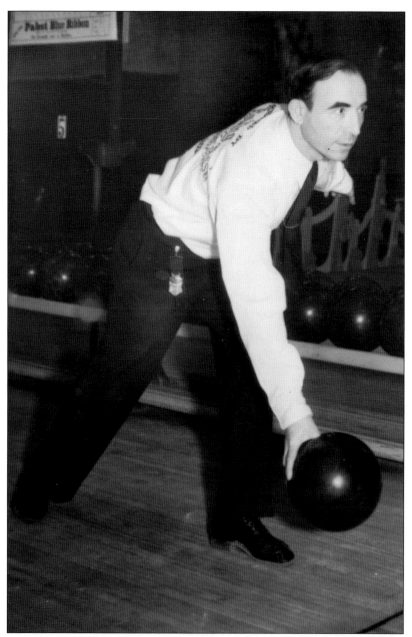

Milwaukee produced a wealth of national champs, too. As a child, Hank Marino played *bocce* in his native Palermo in Sicily. Here, an unusual right-side view showcases his form as he orchestrates the shot. Marino, owner of Marino's Recreation from 1930 to 1964, was a Milwaukee champion like no other. His titles include the 1916 ABC Tournament doubles title with partner Sykes Thoma, the 1925 Peterson Classic, the National Match Game championship from 1935 to 1938, the BPAA National Match Game championship with his team the Heils, and the all-events bowling championship in the 1936 Olympics. He was also honored by the National Bowling Writers Association as "Bowler of the Half Century." In addition to his bowling center in Milwaukee, Marino was part owner of Llo-Da-Mar Bowl in Santa Monica with partners Ned Day and actor Harold Lloyd. (Courtesy of the International Bowling Museum and Hall of Fame.)

In 1951, Hank Marino was honored by the National Bowling Writers Association with the unusual title of "Bowler of the Half Century." It is interesting to note that the award was not only for competitive excellence, but also for constant willingness to impart his own knowledge and abilities, ceaseless efforts to interest new persons in the game, unfailing good humor, unquestioned integrity, constant loyalty, peerless leadership, and a sense of fair play. (Photograph by Manya Kaczkowski, courtesy of the International Bowling Museum and Hall of Fame.)

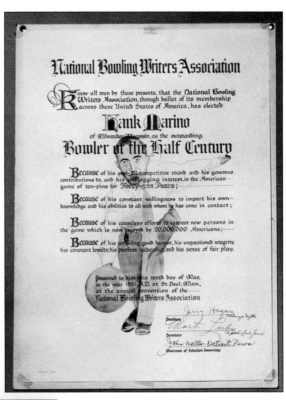

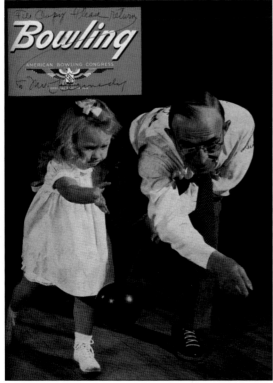

With a bowling ball custom-fit to her size and strength, Hank Marino's granddaughter takes a little instruction from grandpa. Her serious demeanor and concentration graced the cover of *Bowling* magazine in this February 1947 issue—and she still manages to look adorable. Her good form must be in the genes. (Courtesy of International Bowling Museum and Hall of Fame.)

81

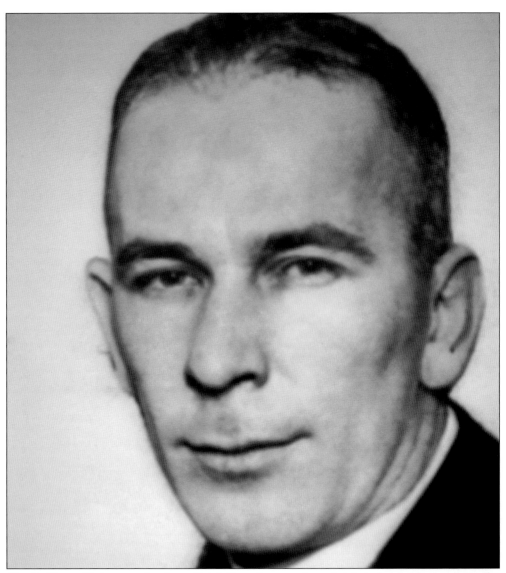

Charlie Daw rolled a mean hook, and his Milwaukee star shone brightly for too short a time—he bowled professionally for only 17 years before he was forced to retire to preserve his health. Daw won the doubles series in the ABC Tournament at the Milwaukee Auditorium with partner Finnes Wilson, and nearly captured the all-events title. His team, the Nelson Mitchells, also won the ABC team championship with a 3,139 series. Then in 1932, with partner Frank Benkovic, Daw won the ABC Tournament doubles crown a second time. He was a member of the famed Heil team, joining the group in Berlin for the 1936 Olympics, and his top series was a more than respectable 801. (Courtesy of International Bowling Museum and Hall of Fame.)

Frank Benkovic won the 1932 ABC Tournament doubles series with Charlie Daw. That same year, he also broke the all-time, all-tournament, all-events record at the Chicago Gold Coast Tournament with a total of 2,259 for nine games. The next year, he captured the ABC Tournament doubles title again, this time with Milwaukeean Gil Zunker. Benkovic is still the only bowler to win the doubles for two consecutive years. His Pabst Blue Ribbon team won the city title in 1937 and the state championship in 1939. He made another state record with an 854 series in the Milwaukee Classic League in 1939. By 1943, Benkovic's ABC Tournament average was 198 over the course of 15 meets, behind only two other bowlers, each of whom averaged 199. (Photographs and scorecard courtesy of International Bowling Museum and Hall of Fame.)

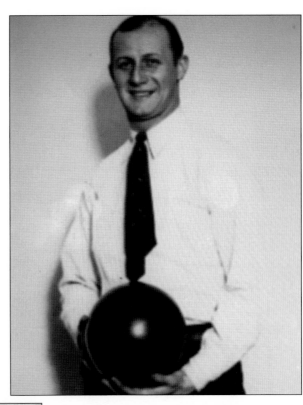

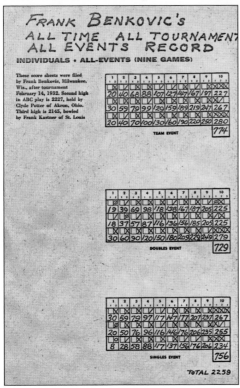

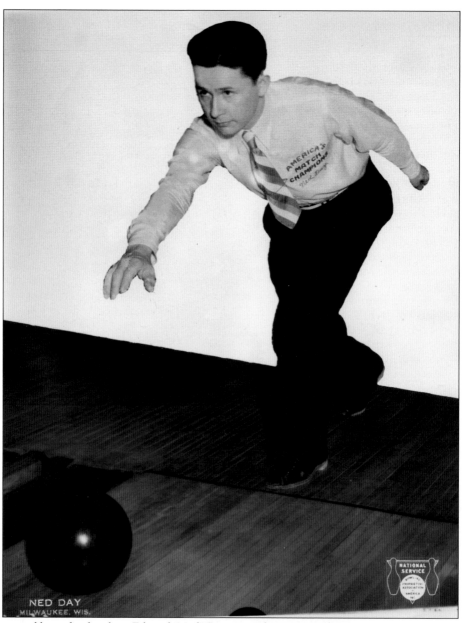

NED DAY
MILWAUKEE, WIS.

A national legend in bowling, Edward "Ned" Day is seen here prior to his proprietor days at Ben-Day Bowl in Milwaukee. He became a star when he defeated his mentor Hank Marino in the National Match game championship in 1938, and he had a career of highs (24 national titles) and lows (gambling losses). A media darling, Day was in many exhibition games across the nation, and was named bowler of the year twice by the Bowling Writers Association of America. He maintained an average of 200 across 28 years and won three ABC Tournament titles, including all-events in 1947; and nine BPAA national championships, including the BPAA All-Star Tournament in 1943. He was on the Heil Products team and made the trip to Berlin for the 1936 Olympics. Day was co-owner of Ben-Day Bowl in Milwaukee, along with several pro shops, but had troubles with illegal gambling rackets and stock market losses. As a bowler, however, Day was admired from both near and far. (Courtesy of International Bowling Museum and Hall of Fame.)

Gil Zunker started out as a bartender at Marino's Recreation and became a star when he won the doubles series with Frank Benkovic and then continued on to nail the all-events prize with a score of 2,060 in the ABC 1933 Nationals. Another member of the famed Heil Products team, Zunker made a name for himself with his 199 average over 13 ABC tournaments. He died, too young, at 37. (Courtesy of International Bowling Museum and Hall of Fame.)

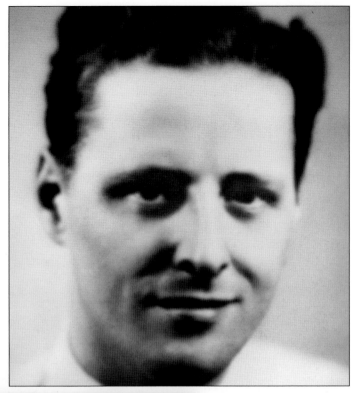

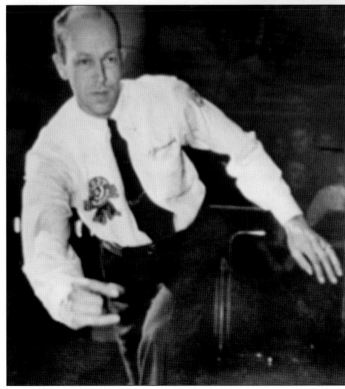

Russ Gersonde grew up bowling in his father's establishment, the Wauwatosa Arcade. Gersonde did his best work during doubles competitions, winning 12 major doubles titles—four of them with Frank Benkovic. Gersonde was a member of several champion bowling teams in Milwaukee: Pabst Blue Ribbon, Clark Oil, and Knudten Paint, along with sportswriter and friend Billy Sixty. His height was 6 feet, 4.5 inches, earning him the nickname "Skyscraper." (Courtesy of International Bowling Museum and Hall of Fame.)

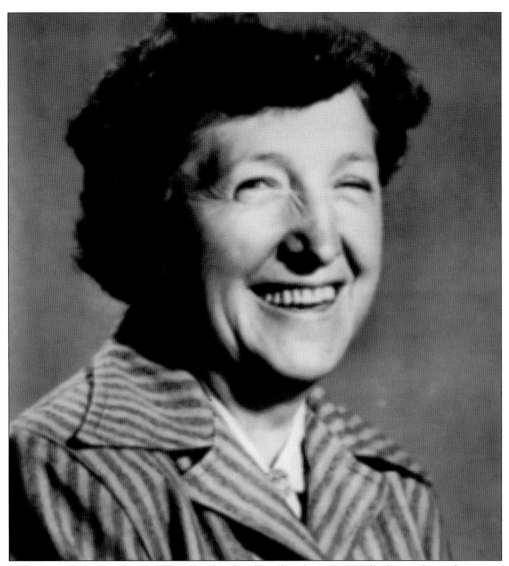

Esther Ryan is the first female Milwaukee bowler elected to the USBC Hall of Fame for performance. The honor was well deserved—she was the winner of two WIBC Championship Tournament titles (1939 and 1947) as well as the all-events title in 1934. In addition to that, she took nine state and 13 local championships. Ryan was a member of the Kornitz Pure Oil team for 23 years and competed in 39 national championships, from 1926 through 1972. She could easily have been elected just on the basis of service; she was secretary of the MWBA for 32 years and was a leading figure in women's bowling on the national scene. (Courtesy of International Bowling Museum and Hall of Fame.)

In 1966, a testimonial dinner was held in honor of Esther Ryan. The star anchor for the Kornitz Pure Oil team from the 1930s to the 1950s was a charter member of the MBWA Hall of Fame. When she took on secretary duties for the MWBA in 1933, the organization had only 393 members. By the time she resigned in 1965, there were 26,162. Ryan was a member of the WIBC Hall of Fame and was named a WIBC "Star of Yesteryear," in addition to making archival donations to the Bowling Hall of Fame museum. She was also the first woman inducted into the WWBA Hall of Fame. (Photographs by Manya Kaczkowski, courtesy of Milwaukee USBC Women's Bowling Association, Inc.)

Congratulations

Whereas,

Mrs. Esther Ryan

Was recently honored by being designated "Guiding Star" of the Milwaukee Woman's Bowling Association for her 32 years of imaginative and dedicated leadership as secretary of the MWBA; and

Whereas, During this three-decade span, Mrs. Ryan assiduously cultivated interest in women's bowling, amply demonstrated by the fact that during her tenure membership in the association rose from 393 members to the present 26,000 bowlers; and

Whereas, An outstanding bowler herself of national stature, Mrs. Ryan in 39 years has won 46 titles, including such highly coveted awards as the national doubles and the national team crowns, twice each, and the national all-events as well as many state and city championships; and

Whereas, Mrs. Ryan recently was named to the Woman's International Bowling Congress hall of fame; and

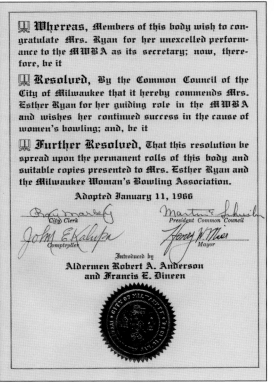

Whereas, Members of this body wish to congratulate Mrs. Ryan for her unexcelled performance to the MWBA as its secretary; now, therefore, be it

Resolved, By the Common Council of the City of Milwaukee that it hereby commends Mrs. Esther Ryan for her guiding role in the MWBA and wishes her continued success in the cause of women's bowling; and, be it

Further Resolved, That this resolution be spread upon the permanent rolls of this body and suitable copies presented to Mrs. Esther Ryan and the Milwaukee Woman's Bowling Association.

Adopted January 11, 1966

City Clerk

President Common Council

Comptroller

Mayor

Introduced by
**Aldermen Robert A. Anderson
and Francis E. Dineen**

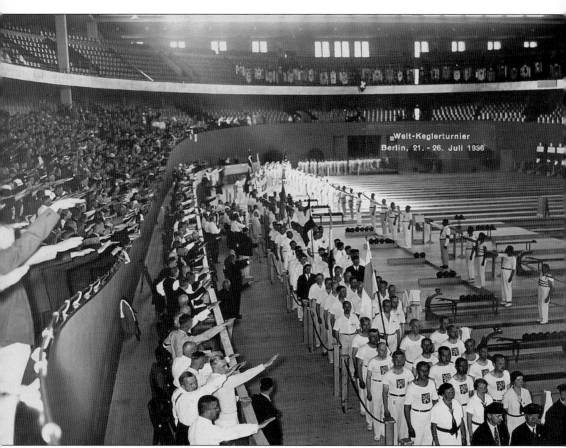

Bowling has never been an Olympic sport, but in 1936 it was allowed into Berlin as an exhibition tournament. Though the games were controversial that year (the world was beginning to disapprove of Hitler), Milwaukee sent the Heil Products team to Germany. In this image, audience members give the *Sieg Heil* ("Hail Victory") sign to welcome teams into the large auditorium. By the looks on the faces of the bowlers as they enter the auditorium, perhaps they were not overjoyed by the Nazi salute. There are also no smiles on the faces of the audience, which was mandated by Hitler to use the salute whether or not they were members of the Nazi party. At that time, not using the salute in Germany was a punishable crime. Use of the *Sieg Heil* salute in Germany today is grounds for arrest and a possible three-year prison term. (Courtesy of Doug Schmidt.)

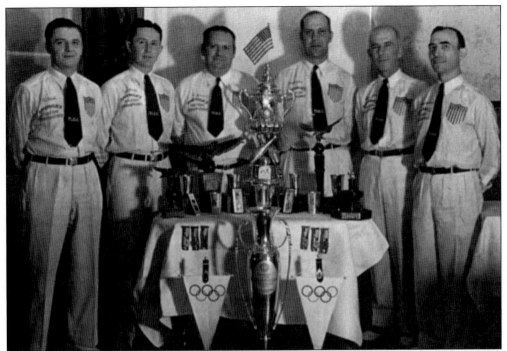

During the 1930s, the Heil Products team included accomplished bowlers Charlie Daw, Ned Day, Edgar Koch, Elmer Koch, Clarence Joner, Hank Marino, Billy Sixty, and Gil Zunker. The Heil Olympic team won 17 trophies, including the team championship. Shown here from left to right, with multiple trophies, are Koch, Day, Joner, Ehlke, Daw, and Marino. (Courtesy of Doug Schmidt.)

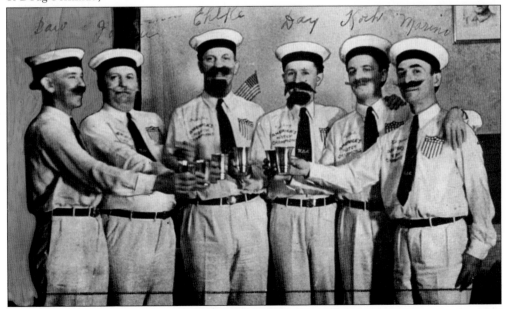

The Heil Products team from Milwaukee sailed aboard the *Europa* on their way to the 1936 Olympics in Berlin. Obviously, they had a sense of humor, or perhaps they sprouted mustaches from drinking all that good German beer. (Courtesy of Doug Schmidt.)

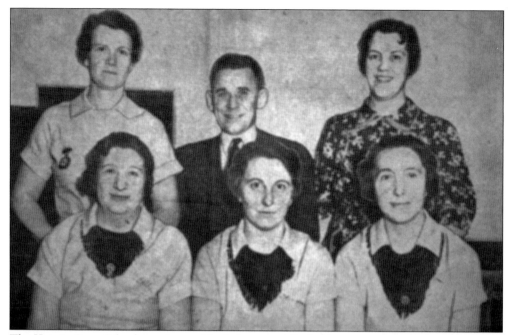

The Kornitz Pure Oils, shown here with their sponsor Rudy Kornitz in the early 1930s, were on their way to becoming a championship team. This photograph was taken when they were about to meet their rivals, the Heil Uniform Heat, in the Arcade Ladies' Classic League. From left to right are (first row) Peggy Ehlke, Ollie Hermann, and Esther Ryan; (second row) Marge Klabunde, Rudy Kornitz, and Flo Kosta. (Courtesy of Milwaukee USBC Women's Bowling Association, Inc.)

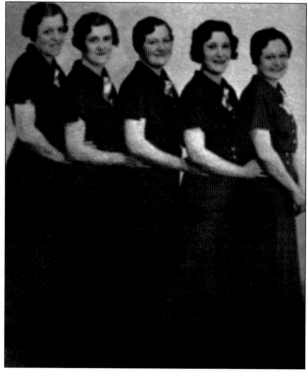

The Heil Uniform Heat team knew how to knock 'em down— they dominated the 1937 and 1938 WIBC Championship Tournaments, with scores of 2,685 and 2,706, respectively. Pictured from left to right are Emmy Dobrient, Irma Jones, Charlene Terzan, Lorraine Baldy, and Gladys Light. (Courtesy of Milwaukee USBC Women's Bowling Association, Inc.)

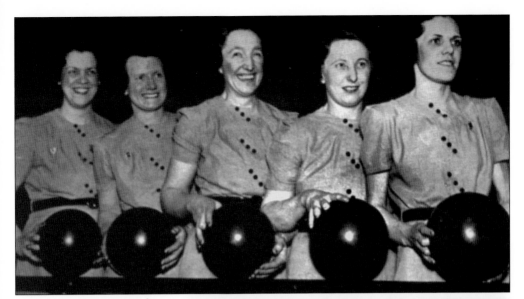

In this 1939 *Woman Bowler* image above, the Kornitz Pure Oils were in the lead at the WIBC 22nd Annual National Tournament in Oklahoma City, taking the title from the Heil Uniform Heat team, which had won the past two years. Shown from left to right are Florence Kosta, Marge Klabunde (captain), Esther Ryan, Olive Herman, and Ade Lindemann. (Courtesy of Milwaukee USBC Women's Bowling Association, Inc.)

Milwaukee was definitely on top during the 1940s. The Kornitz Pure Oil team was about to board a train bound for Syracuse, New York, heading to nationals. Clockwise from bottom left in this *Milwaukee Journal* photograph are Ade Lindemann, Margaret Klabunde, Esther Ryan, Olive Herman, and Flo Kosta. (Courtesy of Milwaukee USBC Women's Bowling Association, Inc.)

Yes, They're From Milwaukee

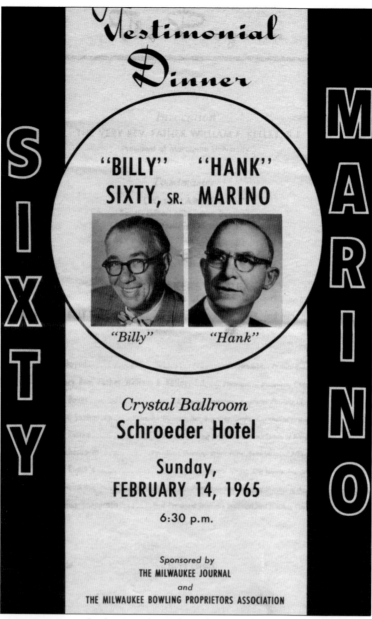

Testimonial
Dinner

"BILLY" "HANK"
SIXTY, SR. MARINO

"Billy" "Hank"

Crystal Ballroom
Schroeder Hotel

Sunday,
FEBRUARY 14, 1965

6:30 p.m.

Sponsored by
THE MILWAUKEE JOURNAL
and
THE MILWAUKEE BOWLING PROPRIETORS ASSOCIATION

SIXTY MARINO

A very important event took place at the Schroeder Hotel's Crystal Ballroom on Valentine's Day, 1965. *The Milwaukee Journal* and the Milwaukee Bowling Proprietor's Association (MBPA) showed their love for both Billy Sixty and Hank Marino in a testimonial dinner honoring the accomplishments of each bowler. Sixty had more than 60 years of sportswriting for both the *Milwaukee Journal* and other publications—his regular column was titled "Going Like Sixty." He began his career by setting pins for a penny per game in Henry Thomas's saloon on Milwaukee's northwest side. Sixty was a champion bowler and amateur golfer, but was also adept at baseball, bicycling, swimming, and tennis. Hank Marino's career as a bowler—and bowling center proprietor—was filled with many accomplishments, awards, and honors, earning him, among other titles, "Bowler of the Half Century" by the National Bowling Writers Association. (Courtesy of the International Bowling Museum and Hall of Fame.)

Five

INVENTIONS, GEAR, AND APPAREL

Walter Choinski operated Choinski's Alleys at Seventh and Mitchell Streets for a number of years, beginning in 1915. He was also an entrepreneur and inventor, coming up with an idea for a ball return machine featuring an apron that would prevent the ball from rolling back down the alley. Choinski filed the patent in 1920 and received approval by August 1921. Here is one of the drawings filed with the patent application. (Courtesy of United States Patent and Trademark Office.)

W. CHOINSKI.
ATTACHMENT FOR BOWLING ALLEY RETURN TROUGHS.
APPLICATION FILED OCT. 26, 1920.

1,388,239.

Patented Aug. 23, 1921.
2 SHEETS—SHEET 2.

In Choinski's device, the returning ball could slide underneath the apron, but would then be caught before it rolled back down the alley, assuming it did not have sufficient oomph to make it up to the top rack. In July 1922, his invention was featured in *Popular Science* magazine. (Courtesy of United States Patent and Trademark Office.)

In this *Milwaukee Journal* photograph, Emil Andel of the ABC checks out an automatic foul detector on a bowling alley in Milwaukee in 1944. The ABC was responsible for maintaining the standards of sanctioned play, and the equipment had to be foolproof. Finally, in 1948, the use of the electric eye was sanctioned by the ABC. In years previous, spotters would be situated on the foul line, to judge whether bowlers had inadvertently crept over the line. (Courtesy of Wisconsin Historical Society.)

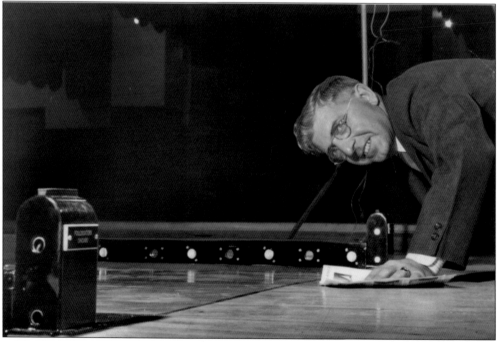

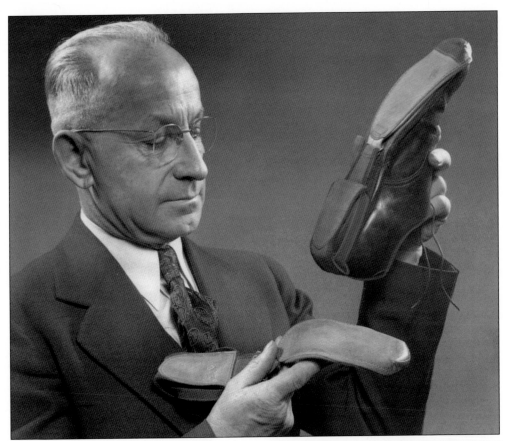

In 1945, Leo Kay, shown above in a *Milwaukee Journal* photograph, invented a slipover rubber bowling sole, allowing bowlers to use their street shoes on the lanes. "Kayglers" were produced by Plastic Specialty Company on Fifth Street in Milwaukee and were marketed to bowling alley proprietors as an alternative to carrying a large supply of bowling shoes. Kayglers could be adjusted to fit any size shoe and were a rather ingenious way to handle the needs of occasional bowlers. The ad shown was displayed in an issue of *National Bowling Journal* from 1945. (Above, courtesy of Wisconsin Historical Society; at right, courtesy of International Bowling Museum and Hall of Fame.)

Oct. 10, 1967
W. H. SCHIMANSKI ET AL
3,346,258
BOWLING PIN WITH FLEXIBLE BELLY
Filed May 18, 1964

PATENTED FEB 15 1972
3,641,687

U.S. Patent Oct. 30, 1984 4,479,648

FIG.1
FIG.2
FIG.3
FIG.4

Bowling inventions kept flowing to and from Milwaukee. The "flexible belly" bowling pin above was a synthetic model featuring a hollow metal core and a plastic coating, with weak spots above and below the area of impact so that the belly would flex inward. According to inventor William H. Schimanski, Brunswick pulled the invention off the table since a more durable pin would have meant less sales activity. The shoe was a handy invention created by William Hibbard of Waupun and Douglas Reeder Jr., of Mequon, backed by the Wisconsin Shoe Company of Milwaukee. A sighting line was sewn into the upper leather of the shoe. Finally, invented and patented by Milwaukeean Martin J. Alivo Jr., this wrist brace was composed of three pieces joined together by a series of velcro straps, designed to prevent movement of the hand relative to the wrist and forearm. The brace would be custom fitted to the bowler. (Courtesy of United States Patent and Trademark Office.)

It was important for wood lanes to be kept in good shape, and Capital Bowling Alley Company in De Forest ran this ad in a 1947 issue of *Bowling* magazine for a "new method" of resurfacing, featuring an alley-wide sander. Now that most lanes are synthetic, resurfacing is far less frequent. (Courtesy of International Bowling Museum and Hall of Fame.)

America's Best Coatings operated out of a shop on North Twelfth Street in Milwaukee, making a product during the 1940s called Plastic Bowl. Said to be the "most durable bowling surface yet known," the company also benefited by using the initials "ABC" in their *Bowling* advertisements. (Courtesy of International Bowling Museum and Hall of Fame.)

Central Lanes (formerly known as Bensinger's West) on Twenty-seventh Street was the location of the National Five-Man Match Championship between Chicago's Meister Brau and Milwaukee's Clark Supply Company teams. It was also one of the many alleys that used America's Best Coatings, Inc., to lacquer the lanes. On the bottom right of this *Bowling* ad, bowler Forrest (Frosty) Sunderland of Milwaukee's Schlitz Brewing team is reported to have rolled a 300 game on Oriental Lanes (formerly Bensinger's Oriental Alleys)—coated, of course, by America's Best Coatings. Although Bensinger's West is no longer in operation, Bensinger's Oriental is now the popular Landmark Lanes on Milwaukee's East Side. (Courtesy of International Bowling Museum and Hall of Fame.)

The first ABC-approved, plastic-coated pin on the market was made by Moore Elasti-Kote Corporation and sold through Better Scores Supply on Thirty-fifth Street and Lisbon Avenue in Milwaukee. This *Bowling Proprietor* ad from 1955 made the claim that plastic-coated pins produced better scores and were more durable. (Courtesy of International Bowling Museum and Hall of Fame.)

Milwaukee's Bowling Pin Service on Walnut Street manufactured the Hi-Box for storage of pins and the Lo-Box, with cutout handles so that pins could be transported and stored easily. This 1947 *Bowling* ad offers them for $1.75 and $2.25, respectively. (Courtesy of International Bowling Museum and Hall of Fame.)

LeRoy McVey "Roy" Bickett and several other businessmen opened the L. M. Bickett Company in nearby Watertown in 1921. They made rubber products, including this bowling alley pit mat, shown in a 1940s *Bowling* ad. Mats were installed at the ends of alleys, thereby cushioning the pins and balls as they fell. (Courtesy of International Bowling Museum and Hall of Fame.)

The J. M. Nash Company was founded in Milwaukee in 1890 by John M. Nash. The sanding machine operations were sold to Crouch Industries in 1986, which still manufactures Nash sanders today. This 1947 *Bowling* ad claims that the Nash No. 87-20 was capable of sanding eight bowling pins per minute. A coarse abrasive removed lacquer, then a finer abrasive and a finishing material was applied. (Courtesy of International Bowling Museum and Hall of Fame.)

This "Magic" Ball Retarder and Return, made by Milwaukee Electronic Controls Company in the 1940s, looks sleek and beautiful in this *Bowling* ad. Made entirely out of metal, with no moving parts, it brought a simplicity to the design, along with a single-ball rack. (Courtesy of International Bowling Museum and Hall of Fame.)

Successful bowlers know that a well-fitted ball is integral to the sport. This measuring ball, although it looks a bit like Swiss cheese, is the type used for years in pro shops across the country. This one harkens from one of the AMF lanes in Milwaukee. Next to it is a Don Carter glove. (Courtesy of Wisconsin Historical Society.)

In this photograph from 1945, a Brunswick bowling alley stub with a manual pinsetter is presented to ABC employees. Although this type of equipment still required a person to load the machine with pins, the days of pin boys were soon to come to an end. The first automatic pinsetters, made by AMF, were shown at the ABC national tournament in Buffalo the next year. They were designed by Gottfried Schmidt and featured suction cups that picked up the pins. Reportedly, those first models weighed more than a ton each. Brunswick came out with its own auto-pinsetter in 1956. (Courtesy of the International Bowling Museum and Hall of Fame.)

In this 1947 *Bowling* ad, Milwaukee and national star Ned Day demonstrates his muscle with a Mineralite ball, featuring the patented "Ned Day Grip." Although the Evertrue was Brunswick's first attempt at a rubber ball, the Mineralite, introduced in 1914, was a true winner in terms of popularity. Day was the first real bowling celebrity, touring the country for widely publicized matches and starring in short films about the sport. He even bowled at the White House during the Truman administration. Day had a good relationship with Brunswick; during the 1950s, his pro shops held exclusive rights to all Brunswick merchandise sold in the state. (Courtesy of International Bowling Museum and Hall of Fame.)

724/334 802 727/334

721/334 800/317 777/334 720/317

BOWLING MEDALS—TROPHIES—AWARDS—SPECIAL DESIGNS DEVELOPED—JEWELERS TO THE AMERICAN BOWLING CONGRESS

BUNDE & UPMEYER JEWELRY MFG. CO.

Plankinton Bldg. Milwaukee, Wis.

In 1880, a partnership was formed between Louis William Bunde and William Henry Upmeyer (ages 21 and 22, respectively). They began manufacturing jewelry and mechanical dentistry—plates and crowns, for example. The pair worked their way into quite a business, eventually opening more than 11,000 square feet of office space in the prestigious Plankinton Building, where they employed more than 100 people. The Fred Smith Recreation Parlor, later known as Plankinton Arcade, offered 41 bowling lanes in the basement of the building. Bunde and Upmeyer was the largest jewelry store in the state of Wisconsin, also specializing in bowling medals, trophies, and jewelry for the industry. (Courtesy of International Bowling Museum and Hall of Fame.)

Erffmeyer and Son Company, Inc., or ESCO as they are traditionally known, has been in business in Milwaukee since 1934, taking over the medals and trophy business from Bunde and Upmeyer in the 1940s. This *Bowling* ad shows a fairly elaborate trophy for $36. ESCO is still in business today, producing jewelry, awards, and gifts. (Courtesy of International Bowling Museum and Hall of Fame.)

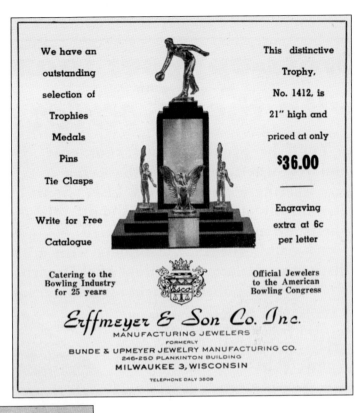

A local jeweler, Edward R. Kosobucki, operated out of his shop on Brady Street. Most interesting about this sales slip from 1945 is the low pricing. These appear to have been trophy plates, although the round ring for just $4.05 is intriguing. (Courtesy of University of Wisconsin-Milwaukee.)

Sometimes product manufacturers did occasional runs of items that were different from anything else they made. Such was the case with this Milsco Manufacturing belt in this ad from *Bowling* magazine. The company, founded by Carl T. Swenson in 1924, originally made harnesses, horse collars, and saddles, then became quite successful at making leather tractor seats. During World War II, they set civilian work aside and focused solely on making products for the U.S. military. After the war, they sold off the harness business, going back to seating and specialty items, such as these belts that sold for $3.50 apiece. Milsco Manufacturing is still headquartered in Milwaukee, with additional facilities in Wisconsin, Georgia, Michigan, England, and Mexico. (Courtesy of International Bowling Museum and Hall of Fame.)

Since the early 1900s, Walsh Harness has been famous for its no-buckle horse harness, and the saddlery company is still in the Milwaukee area. One would be hard-pressed to get a bowling bag out of them these days, but the one in this *Bowling* ad from the 1940s, with its elk sides and cowhide center, was beautiful. (Courtesy of International Bowling Museum and Hall of Fame.)

LEATHER BOWLING BAGS

These new bags by Walsh possess striking beauty of design, materials, and workmanship. Rigid leather ring cup for ball, on 1/4" best grade plywood base. Trouble-free 20" zipper opener. Walsh bags do not sag—always erect and ready to receive ball and accessories.

Snappy two-tone with full grain Brown Elk sides, and full grain Russet Cowhide center—12" or 14" base. Also in Stand-up style—6" base.

DEALERS! Increase sales and profits with new Walsh line.

Write NOW for circular and prices.

LEATHER GOODS DIVISION

WALSH HARNESS CO.
Milwaukee 10, Wisconsin

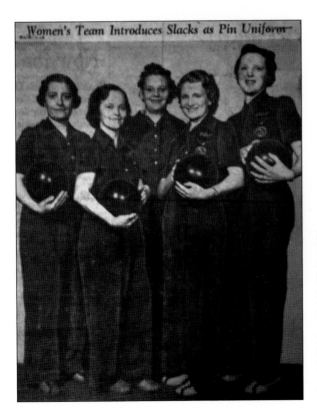

Women's Team Introduces Slacks as Pin Uniform

Speaking of great style, the Haack bowling team had a leg up on the times—they were bold enough to begin wearing slacks as their uniform in 1939. The Haacks bowled at Rogahn's in Bay View. Shown from left to right in this *Milwaukee Journal* photograph are Ruth Prickett, Catherine Oilermann, Doris Nacker, Helen Kuehn, and Ethel Wilkens. (Courtesy of Milwaukee USBC Women's Bowling Association, Inc.)

This pretty pair was all set to take the lanes by storm in shorts—a first for Milwaukee in 1939. Doris Gallus (left) and Esther Mainville, pictured in this *Milwaukee Sentinel* photograph, bowled in the Boston Store League at Marino's Recreation on Thursday nights. Shorts were still pretty daring in the 1930s, although actresses like Katherine Hepburn had been wearing trousers in the movies for several years. There was a garment called the playsuit, which was a one-piece romper similar to a gym suit, but this sporty duo was on the cutting edge of fashion with their spunky two-piece ensembles—and in conservative Milwaukee, no less. (Courtesy of Milwaukee USBC Women's Bowling Association, Inc.)

Brill bowling shirts were made in Milwaukee in the 1930s, and then again after the company did a stint producing uniforms for the U.S. armed forces from 1941 until the end of World War II. Their ads, like this *National Bowlers Journal and Billiard Review* ad from 1945, appeared frequently in major bowling magazines and in the sports section of the *Milwaukee Journal*. (Courtesy of the International Bowling Museum and Hall of Fame.)

By 1947, Brill's bowling shirt division had come up with a modern "Bowlinknit" shirt, using Brill rayon and cotton, said to breathe and retain its shape. Note the other fancy names for their bowling shirts in this *Bowling* ad: the Bo-Wooler and the Zephyr-Range. (Courtesy of International Bowling Museum and Hall of Fame.)

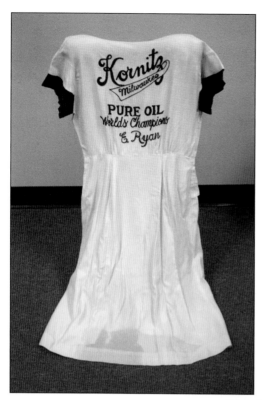

These two relics, retired and preserved after years of making bowlers look good on the lanes, have seen much action. The dress was worn by Esther Ryan, the lynch pin for the Kornitz Pure Oil team in Milwaukee. Ryan donated many of her dresses to the National Bowling Hall of Fame in the 1970s, and they have now made their way to the International Bowling Museum and Hall of Fame in Arlington, Texas. The Blatz shirt was worn by a member of one of the Blatz bowling teams sponsored by the brewery over the years. All of the major breweries in Milwaukee—Blatz, Miller, Schlitz, and Pabst—recruited top local talent for their teams. (Photographs by Manya Kaczkowski, courtesy of International Bowling Museum and Hall of Fame.)

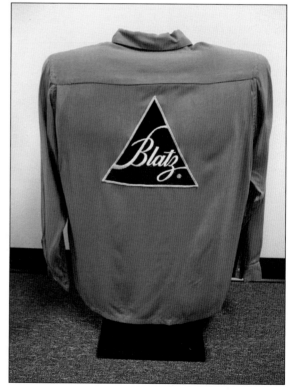

Six

BLASTS FROM THE PAST

These three establishments are still going strong in Milwaukee. Falcon Bowl (originally Listwan's Alleys) sports the Polish Falcons sign on its building. Bay View Bowl (originally Rogahn and Roloff's Alleys) draws a lively neighborhood crowd, while the Holler House (originally Mike's Tap) remains virtually unchanged from its inception, all the way down to the ancient alleys in the basement. (Photographs by Manya Kaczkowski.)

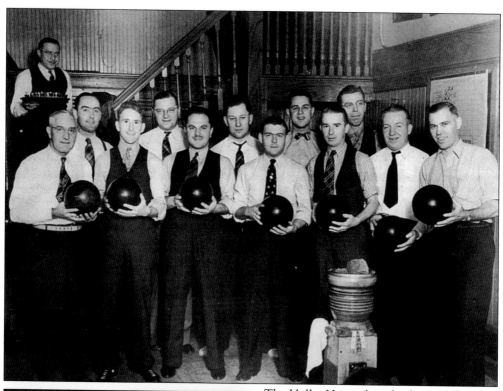

The Holler House dates back to 1908, when Iron Mike Skowronski (on the top left in this *Milwaukee Journal* image) and his wife bought the building for $10,000. During Prohibition, they kept customers happy by hiding the alcohol under the baby crib in case of a raid. Today customers can belly up to the same old bar for a cold one. Iron Mike was a tough guy—he weighed 145 pounds, but was known to throw much larger ruffians right out of the bar. (Courtesy of Doug Schmidt.)

The two lanes in the basement still look pretty much the same as when grandma used to scrub them on her hands and knees in the early 1900s. The lanes are still wood, bowlers keep their own score, and real live pin boys set the pins back up. Marcy Skowronski, Iron Mike's daughter-in-law, can tell tales about pin boys who received their tips at the end of a game by way of bills stuffed into the holes of a bowling ball, which would then be rolled down the lanes to them. (Photograph by Manya Kaczkowski.)

Marcy Skowronski (also known as the "Polish Queen") and Holler House both have plenty of fans. At age 84, Skowronski still plans outings, special events, and luncheons for her customers, including excursions to the racetrack, spaghetti dinners, and holiday parties. It is usually too hot to bowl downstairs in the summer as there is no air conditioning, but in spring, fall, and winter, she will get a neighborhood kid to set pins for bowlers who call ahead. (Courtesy of Doug Schmidt.)

In addition to leagues and open bowling, the Holler House has regulars—several generations of them. Customers aren't afraid to share their love of the lanes, as evidenced by this sentiment. The wall to the right of the lanes is filled with love notes, giving its own version of Milwaukee bowling history. (Photograph by Manya Kaczkowski.)

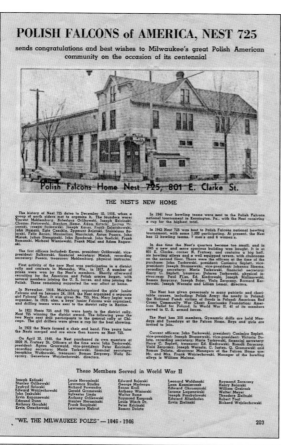

The Polish Falcons of America, a fraternal organization dedicated to providing financial and fraternal benefits to those of Polish descent, purchased a building at 801 East Clarke Street in 1945 for their "nest." The building, formerly Listwan's Alleys, has six lanes in the basement that date from at least 1899, when Paul Listwan operated the alleys. The lanes were first certified in 1913. (Courtesy of Falcon Bowl.)

Today the lanes at Falcon Bowl remain largely unchanged from the old days. There are still wood alleys and scores are still recorded on paper. In addition to bowling, there's a dartball league on Wednesday nights and a cribbage league during the winter season. (Photograph by Manya Kaczkowski.)

Bob E Lanes, on South Thirteenth Street, first opened its six alleys in 1923 as Pyszcznski's, and then became Romie's Alleys in 1949. Romie's sponsored its own team of talented bowlers. In 1958, they won the state championship with a 3,023 total and also high scratch, with a score of 2,899. (Courtesy of Milwaukee Public Library.)

The name Bob-E-Lanes comes from Bob and Elaine Rydzewski, who bought the place in the 1970s. Their son Jim has owned it for nearly 30 years now, and the six sweet little lanes still pose a challenge. In the old days, after a long day at the factory, regulars would make the circuit after work—one or two beers at Bob-E-Lanes, then Walker's Maple Grove, then Manitoba Lanes. In this image, an end-of-the season tournament is underway. (Photograph by Manya Kaczkowski.)

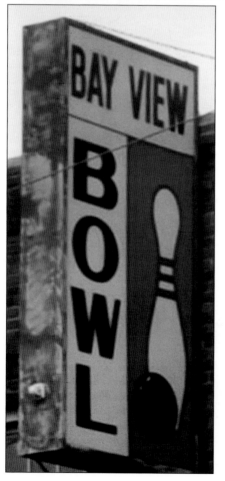

Rogahn and Roloff's Alleys was established in 1925 in a section of Milwaukee known as Bay View. There have been hundreds of tournaments played and many 300 games rolled over the years, fostering several generations of bowling fanatics. Competition was—and still is—serious here, and you still see the window where errant bowlers were penalized when they stepped out an inch too far. (Courtesy of USBC.)

Current owner Mike Kozinski loves bowling. Before buying Bay View Bowl (originally Rogahn and Roloff's Alleys), he worked there (as well as at Olympic Lanes and American Serb Hall). He remodeled the place a little at a time, adding new walls, ceilings, bathrooms, and other improvements. Leagues are the strong suit of Bay View Bowl, and the Wednesday night league has been in place for 30 years. The lanes are still wood, but now there is auto-scoring. (Photograph by Manya Kaczkowski.)

The Oriental Theater and Bensinger's Recreation, built on the site of a former horse, mule, and streetcar barn in 1927, had a total of 21 lanes, 16 of which remain in operation today. Shown above are the five lanes that were converted, in the 1940s, to a back bar with seating and pool tables. (Courtesy of Milwaukee County Historical Society.)

The plan was to showcase a brand new Strachota's Milshore Bowl for the WIBC "Silver Jubilee" in 1942, but because steel was in high demand for war manufacturing, the Milshore lanes were not completed until 1948. This ad from *The Woman Bowler* announces the 30 alleys at the other Bensinger's Recreation (Bensinger's West) as the tournament site. Because of the war, WIBC officers met at the Milwaukee Auditorium sans evening gowns. (Courtesy of Milwaukee USBC Women's Bowling Association, Inc.)

Today on a wall inside Landmark Lanes, there are movie posters for *The Big Lebowski* and *King Pin* and a plaque memorializing Ola ("Big O") Thomas: "She skidded sideways, chocolate in one hand, VO in the other, screaming, 'Woo Hoo, what a ride!'" In addition to league rollers, many celebrities have bowled here, including Ringo Starr, Gloria Steinem, Todd Rundgren, and Nora Jones. Drinks are cheaper at the three bars here than in the surrounding taverns, so the place is always hopping. There are 16 lanes remaining of the original 21, as well as pool and dart leagues. (Photograph by Manya Kaczkowski.)

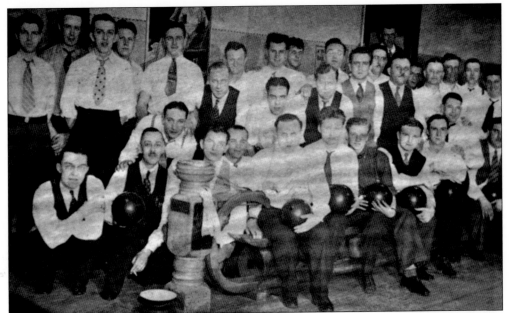

The 835 league at the Cudahy Bowling Center poses here in the mid-1930s. Joseph Fojtik, whose father built the bowling alley in 1924, is seated fifth from the right. His father sold the lanes in 1933, but Fojtik and his brother Charles (Chic) ended up taking possession again in 1954, both mortgaging their homes to make the purchase. (Photograph by Ervin Budzien, courtesy of Motion Plus.)

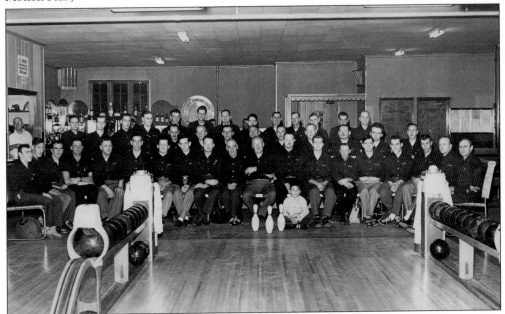

Cudahy Bowling Center has had many talented bowlers over the years—perhaps the most well known is Herb Arndt, who retired from bowling at the ripe old age of 91. When the alleys were repeatedly passed over as the site for Milwaukee's City Tournament, they insisted on receiving their own ABC charter, along with several other far south establishments. These bowlers meant business. (Courtesy of Motion Plus.)

Former professional bowler Carey Catania's story has a familiar ring—prior to owning Motion Plus Lanes (formerly Cudahy Bowling Center), he worked for Bluemound Bowl, Silver City Recreation, and Root River Lanes. Then, after owning his own remodeling business for a while, he turned back to his first love and became a bowling alley proprietor. (Photograph by Manya Kaczkowski.)

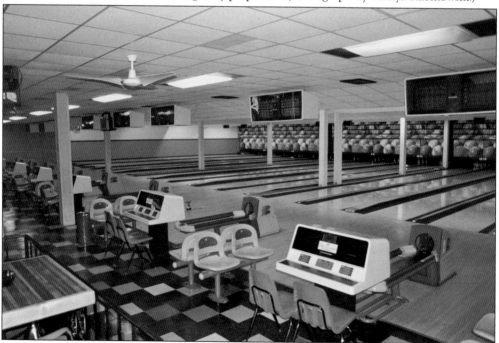

After a year of getting to know the league bowlers and other customers at Motion Plus, Catania got to work. He installed new lanes, assembled a competent staff, attracted more league bowlers, and turned Motion Plus into a busy, attractive recreation center. (Photograph by Manya Kaczkowski.)

The South Milwaukee Arcade is located on the historic Yellowstone Trail, which from 1915 to 1930 was a long-distance travel route stretching from the East Coast to Yellowstone National Park. The 10 lanes opened in 1923, joining Cudahy Bowl in its independent ABC charter in the 1960s. (Photograph by Manya Kaczkowski.)

Ed Vahradian Jr., current owner of Ed's South Milwaukee Arcade, grew up bowling. His parents owned the lanes since 1972, and he took them over in 2001. He has made many improvements to the lanes, the equipment, and also the furniture since then. Most of the leagues are sanctioned, and Vahradian says he sees about five 300 games rolled in his bowling alley each year. (Photograph by Manya Kaczkowski.)

Some 60 years later, the 12 lanes at American Serb Hall remain astonishingly similar to this photograph from the 1950s. Serb Hall has had its share of tournaments and press. *Bowling With the Champs* was filmed here on Sundays from 1958 to 1962, and many politicians have either bowled or spoken here, including John and Jackie Kennedy, Dwight D. Eisenhower, Richard Nixon, Gerald Ford, Jimmy Carter, Lyndon Johnson, Ronald and Nancy Reagan, George Bush, and Bill Clinton. (Courtesy of American Serb Hall.)

American Serb Hall began with a church. The St. Sava Serbian Orthodox Church began meeting in a renovated building on Third Street in Milwaukee, serving the growing number of Serbian immigrants in the area. American Serb Hall was built in 1950 on Oklahoma Avenue in honor of the young Serbian Orthodox men who served with the U.S. armed forces—15 of whom lost their lives. In 1955, the beautiful St. Sava Serbian Orthodox Cathedral was completed next to Serb Hall, where it still stands today. (Photograph by Manya Kaczkowski.)

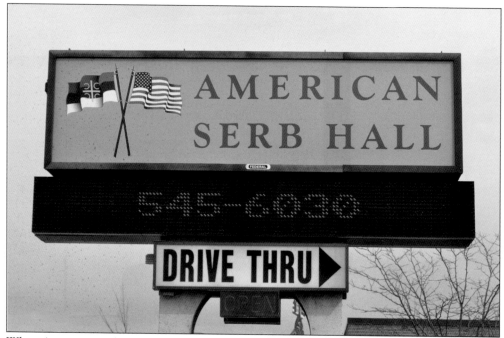

When American Serb Hall opened in 1950, it was the most modern facility on the entire South Side. Besides bowling, another customer magnet is the Friday night fish fry, going strong since 1967. Approximately 2,000 pounds of fish are now served in the hall every Friday, and there is a handy drive-through window, too. (Photograph by Manya Kaczkowski.)

In 1984, the *Milwaukee Sentinel* captured Vice Pres. George Bush as he stumbled at American Serb Hall, where he had stopped to bowl a game or two. The spill was rumored to happen because of the right-handed shoes he was given—he's a lefty (except for his politics). Luckily, only his pride was injured. (Courtesy of American Serb Hall.)

Morty's Bowl and Bar, opened by Morty Smith in the late 1940s, was the former site of the Muskego train depot for the Milwaukee Railway and Light Company. Electric trains brought people from Milwaukee to Muskego to enjoy the resort atmosphere at Muskego Lake and to visit the Muskego Beach Amusement Park. The image above, taken during a 1920s winter, shows the outlines of the snow-covered track in the foreground. The building also held a six-room boardinghouse and a bar. In later years, the building caught fire and the top floor was destroyed. The photograph below shows the train bound for East Troy from Milwaukee, stopping to pick up mail in Muskego. (Both courtesy of Charles H. Damaske.)

Some years after the electric trains stopped rolling into Muskego, the depot was turned into a bowling alley. Current owners Tom and Marlene Mather bought the lanes in 1972. They haven't succumbed to installing auto-score machines yet, but the lanes are kept in good shape and the ball returns have been replaced. Like most proprietors, the Mathers love to bowl; each is in three leagues. Marlene Mather, who serves as bowling instructor for the junior leagues, says that many of those kids stay on at the lanes after they grow up, joining adult leagues in their 20s. The outdoor décor is a testament to the owners' passion for the sport. (Photograph by Manya Kaczkowski.)

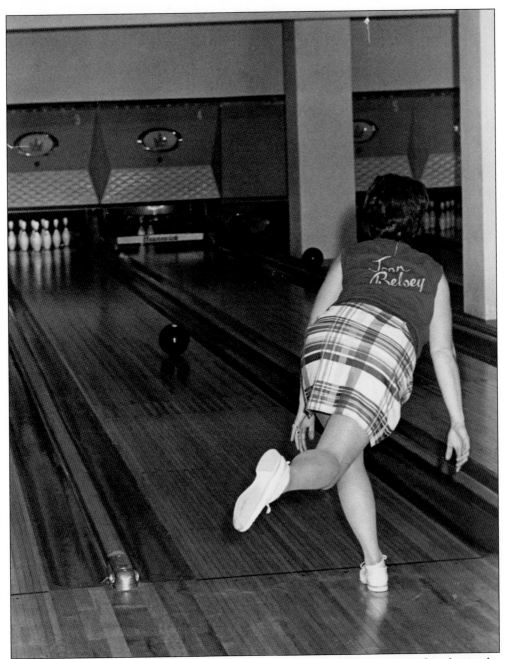

This bowler, throwing a slight hook at the Milwaukee Athletic Club, is a reminder of a simpler time, when underground music was the crash of pins in a basement, when social networking happened every Tuesday night at the lanes, when children truly followed in their parents' footsteps . . . down the alleys. Luckily, some of these classic gems remain in Milwaukee. But visit them now, because in the last 20 years, 34 bowling centers have closed in Milwaukee. (Courtesy of Milwaukee Athletic Club.)

www.arcadiapublishing.com

MAP SEARCH

Discover books about the town where you grew up, the cities where your friends and families live, the town where your parents met, or even that retirement spot you've been dreaming about. Our Web site provides history lovers with exclusive deals, advanced notification about new titles, e-mail alerts of author events, and much more.

MADE IN THE USA

Arcadia Publishing, the leading local history publisher in the United States, is committed to making history accessible and meaningful through publishing books that celebrate and preserve the heritage of America's people and places. Consistent with our mission to preserve history on a local level, this book was printed in South Carolina on American-made paper and manufactured entirely in the United States.

This book carries the accredited Forest Stewardship Council (FSC) label and is printed on 100 percent FSC-certified paper. Products carrying the FSC label are independently certified to assure consumers that they come from forests that are managed to meet the social, economic, and ecological needs of present and future generations.

FSC
Mixed Sources
Product group from well-managed
forests and other controlled sources

Cert no. SW-COC-001530
www.fsc.org
© 1996 Forest Stewardship Council

Find Your Place in History.